CUT
PAPER
PICTURES

This book is dedicated to the Robin family and all its extended members, without whom I never would have had the inspiration to create the paper cut worlds I continue to make. To Poppy, and the bottomless cake, wine, camping, sea swims, and experiences that continue to fill my heart with endless joy and inspiration, and to Kev, for his unfaltering optimism and championing of what I do, adventuring partner in crime, and solid rock of pure patience and kindness without whom I could not have put this book together.

CONTENTS

INTRODUCTION

Cutting and collage has always appealed to me. To this day, I remember how proud I felt at age five when my first teacher told me how proficient I was at cutting. (Thank you very much, Mrs. Hansford!) But I knew I was completely hooked when I got to high school and college, and was surrounded by incredible, supportive teachers with enthusiasm for art and crafts.

After a few years experimenting with different mediums, I completed a Bachelor of Arts degree in Surface Pattern Design at Leeds College of Art and Design. With a bit of tech knowledge under my belt, I left the rolling hills of West Yorkshire, England, moved to London, and then went on to complete a Master of Arts degree at Central Saint Martins in Future Textile Design. This cemented my passion for a more craft-based approach to art and design.

I completed a couple of internships and part-time jobs with large design firms specializing in print and pattern, but deep down knew that I wanted to create my own work, based on personal experiences rather than what the trends predicted. So I packed up my craft kit, got a job in a museum gift shop to pay the bills, and started snipping the things that inspired me. This led me on a voyage of discovery, and at this point the artists, designers, and styles that had influenced my work really began coming into play. Folk art, botanical art, and mid-twentieth-century design all translate very well into collage, and have the qualities of both charm and joy that succinctly capture the beautiful moments of everyday life. I began to miss terribly the beaches, forests, and moors of Devon, England, where I grew up—and while these places had been an inspiration for most of my work, nature became the most prominent feature in my art during this period.

As I developed my style, I began to find jobs that previously I could have only ever dreamed of. Soon, I began to earn money from what I loved doing. Today, my creative career grows with every assignment, and with it grows my deep love of collage as a medium. Collage has been a popular medium for years, used by many artists throughout history—famously, Pablo Picasso, Peter Blake, and Henri Matisse. The term comes from the French *papier collés*, which literally means "glued paper." But paper is only one of the many things you can collage—fabrics, ephemera, and photographs, which have always been a part of collage, add depth and dimension.

Collage enables one to construct intimate snapshots of the world using anything lying around, from old bits of paper to envelopes, tickets, leaflets, fabric, and photos. With collage, you can create a picture organically, simply by moving pieces around your page, and then building and layering a story, or perhaps a place of your own making. That's why collage has become my discipline of choice: it allows me to create a three-dimensional picture with a tactility and depth that I have never been able to fully produce with digital equipment, or by sketching and drawing alone. Stroking my hands over the uneven cut surface has become a sort of ritual at the end of every piece, feeling all the unique bumps and ridges, which could only have been produced by my hand. These tiny, tangible differences add individuality, identity, and energy to my art.

With this book, I want to share a little of my paper cut world with you and give gentle direction as to how to create your own. I'll review the materials I use, introduce you to the things I like to collage the most, and create a collage based on photography. I hope that you enjoy both the results and the experience of immersing yourself in this process. Embrace the individuality of your collage art. It, like you, is made of many pieces and layers, and the joy that comes from its creation is the joy that comes from being yourself.

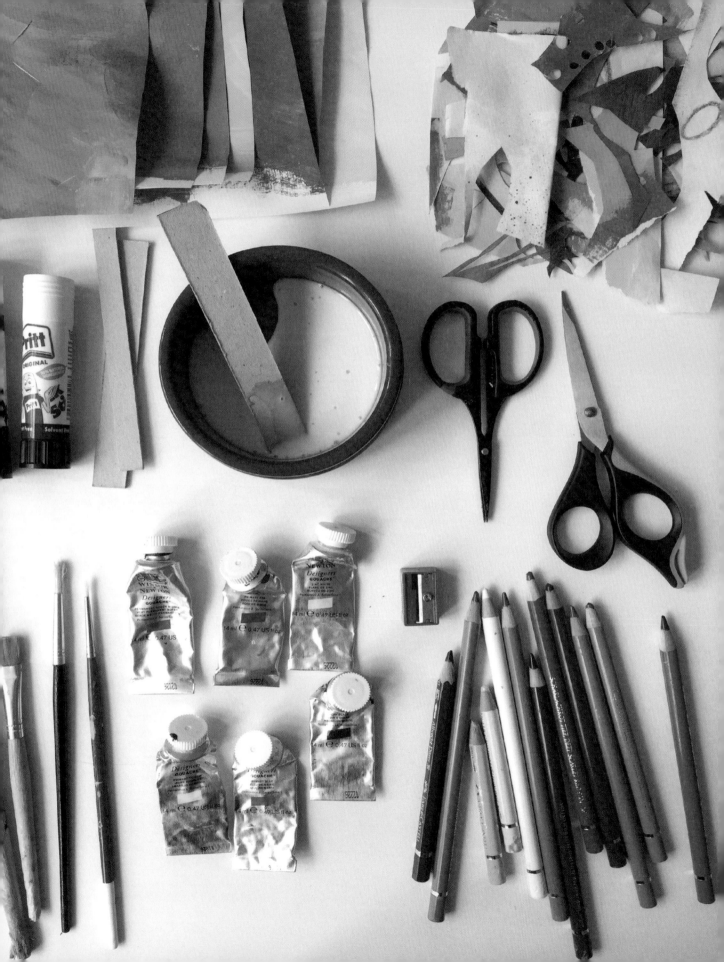

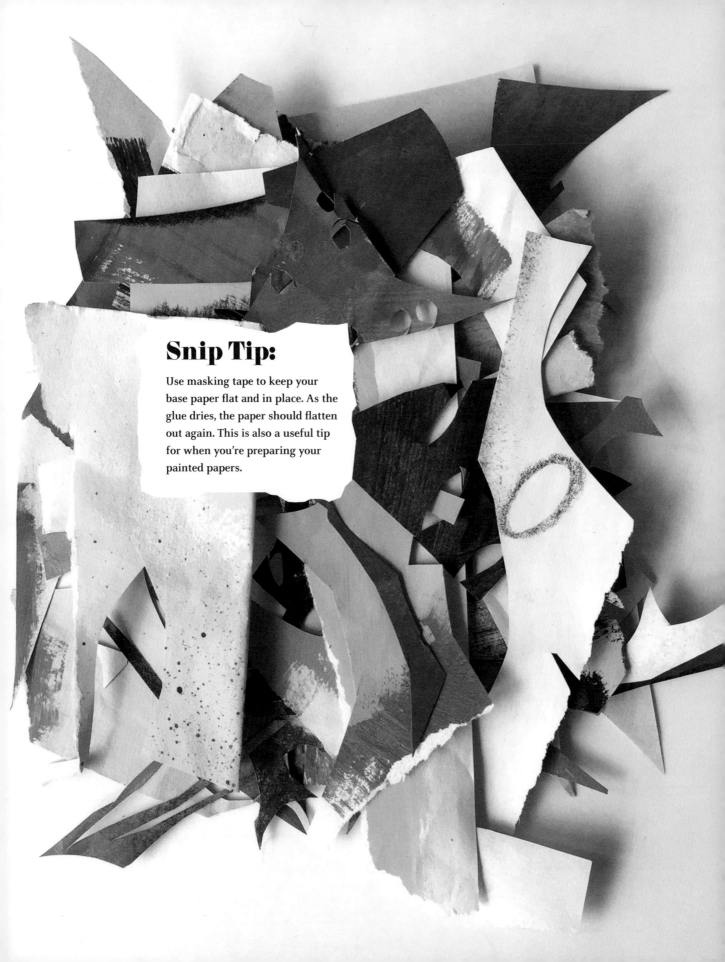

Snip Tip:

Use masking tape to keep your base paper flat and in place. As the glue dries, the paper should flatten out again. This is also a useful tip for when you're preparing your painted papers.

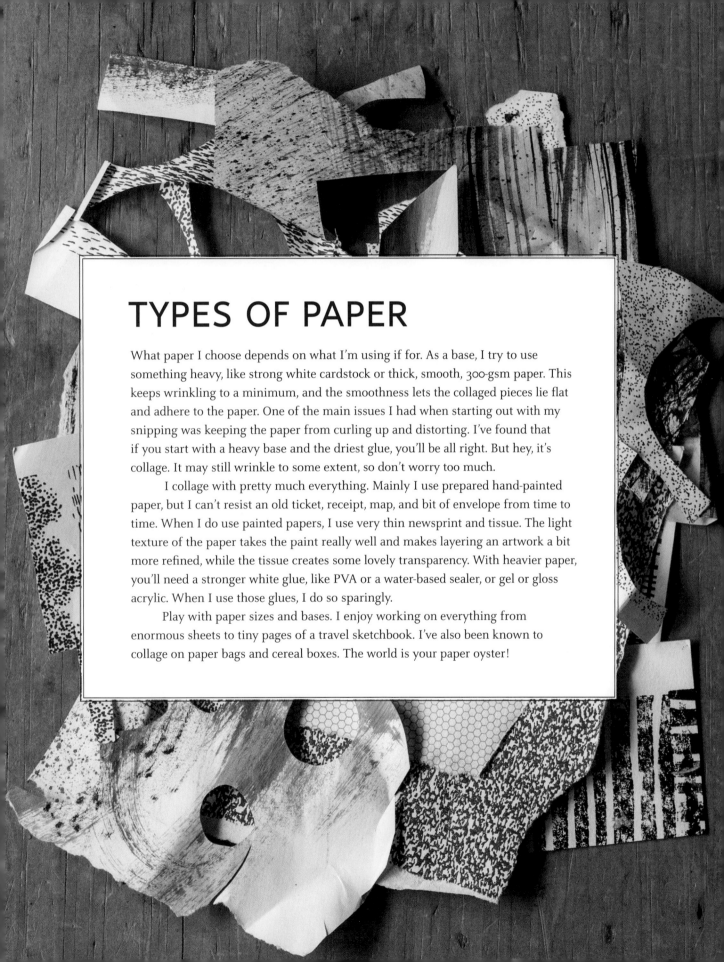

TYPES OF PAPER

What paper I choose depends on what I'm using if for. As a base, I try to use something heavy, like strong white cardstock or thick, smooth, 300-gsm paper. This keeps wrinkling to a minimum, and the smoothness lets the collaged pieces lie flat and adhere to the paper. One of the main issues I had when starting out with my snipping was keeping the paper from curling up and distorting. I've found that if you start with a heavy base and the driest glue, you'll be all right. But hey, it's collage. It may still wrinkle to some extent, so don't worry too much.

I collage with pretty much everything. Mainly I use prepared hand-painted paper, but I can't resist an old ticket, receipt, map, and bit of envelope from time to time. When I do use painted papers, I use very thin newsprint and tissue. The light texture of the paper takes the paint really well and makes layering an artwork a bit more refined, while the tissue creates some lovely transparency. With heavier paper, you'll need a stronger white glue, like PVA or a water-based sealer, or gel or gloss acrylic. When I use those glues, I do so sparingly.

Play with paper sizes and bases. I enjoy working on everything from enormous sheets to tiny pages of a travel sketchbook. I've also been known to collage on paper bags and cereal boxes. The world is your paper oyster!

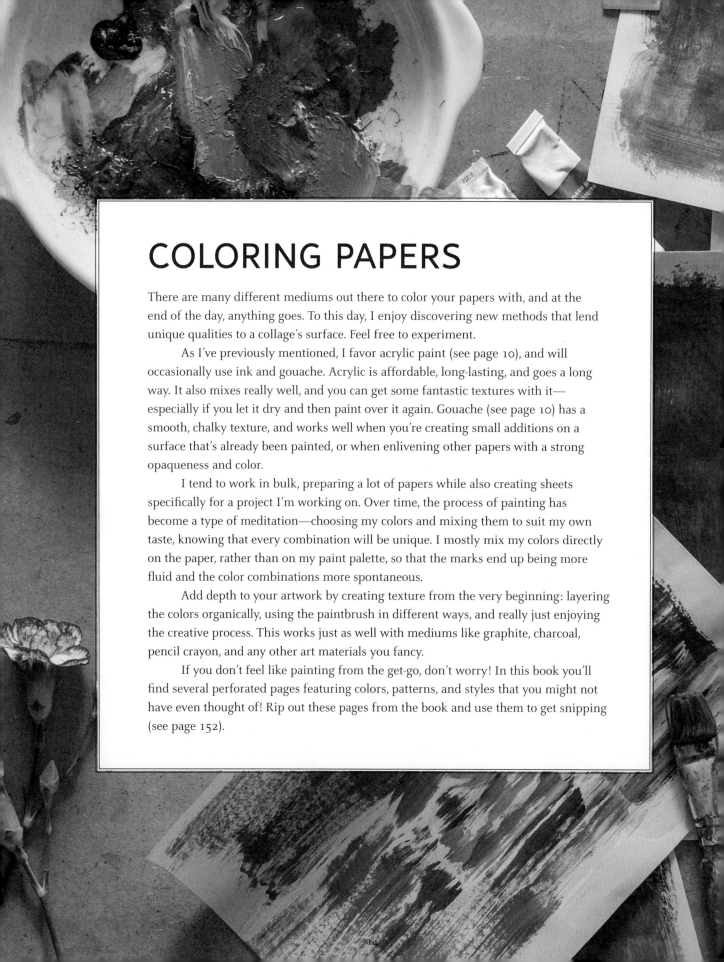

COLORING PAPERS

There are many different mediums out there to color your papers with, and at the end of the day, anything goes. To this day, I enjoy discovering new methods that lend unique qualities to a collage's surface. Feel free to experiment.

As I've previously mentioned, I favor acrylic paint (see page 10), and will occasionally use ink and gouache. Acrylic is affordable, long-lasting, and goes a long way. It also mixes really well, and you can get some fantastic textures with it—especially if you let it dry and then paint over it again. Gouache (see page 10) has a smooth, chalky texture, and works well when you're creating small additions on a surface that's already been painted, or when enlivening other papers with a strong opaqueness and color.

I tend to work in bulk, preparing a lot of papers while also creating sheets specifically for a project I'm working on. Over time, the process of painting has become a type of meditation—choosing my colors and mixing them to suit my own taste, knowing that every combination will be unique. I mostly mix my colors directly on the paper, rather than on my paint palette, so that the marks end up being more fluid and the color combinations more spontaneous.

Add depth to your artwork by creating texture from the very beginning: layering the colors organically, using the paintbrush in different ways, and really just enjoying the creative process. This works just as well with mediums like graphite, charcoal, pencil crayon, and any other art materials you fancy.

If you don't feel like painting from the get-go, don't worry! In this book you'll find several perforated pages featuring colors, patterns, and styles that you might not have even thought of! Rip out these pages from the book and use them to get snipping (see page 152).

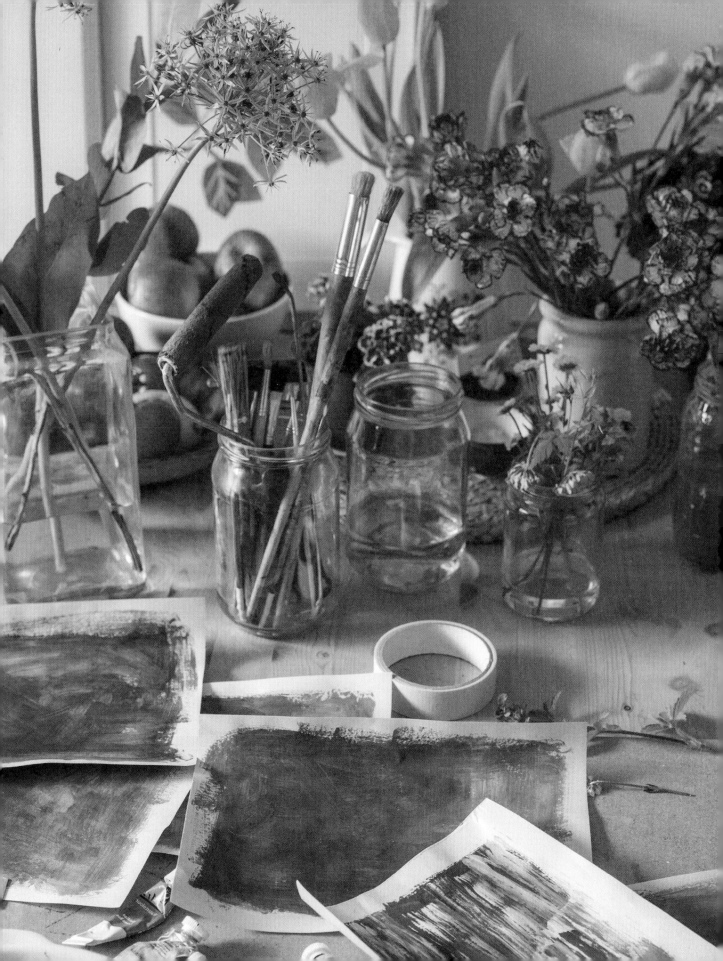

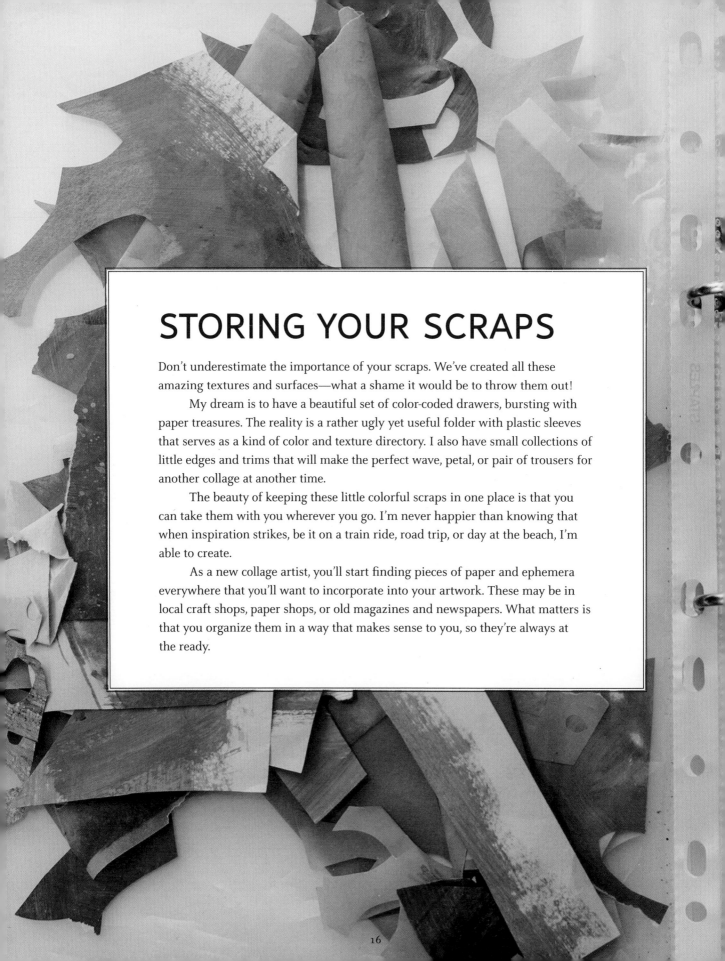

STORING YOUR SCRAPS

Don't underestimate the importance of your scraps. We've created all these amazing textures and surfaces—what a shame it would be to throw them out!

My dream is to have a beautiful set of color-coded drawers, bursting with paper treasures. The reality is a rather ugly yet useful folder with plastic sleeves that serves as a kind of color and texture directory. I also have small collections of little edges and trims that will make the perfect wave, petal, or pair of trousers for another collage at another time.

The beauty of keeping these little colorful scraps in one place is that you can take them with you wherever you go. I'm never happier than knowing that when inspiration strikes, be it on a train ride, road trip, or day at the beach, I'm able to create.

As a new collage artist, you'll start finding pieces of paper and ephemera everywhere that you'll want to incorporate into your artwork. These may be in local craft shops, paper shops, or old magazines and newspapers. What matters is that you organize them in a way that makes sense to you, so they're always at the ready.

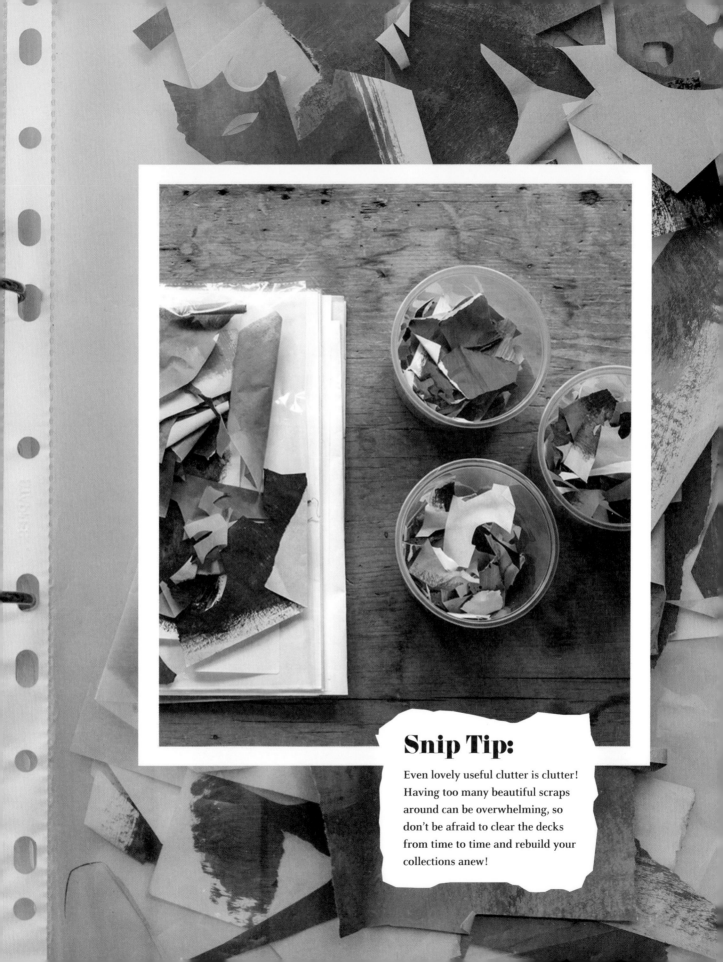

Snip Tip:

Even lovely useful clutter is clutter!
Having too many beautiful scraps
around can be overwhelming, so
don't be afraid to clear the decks
from time to time and rebuild your
collections anew!

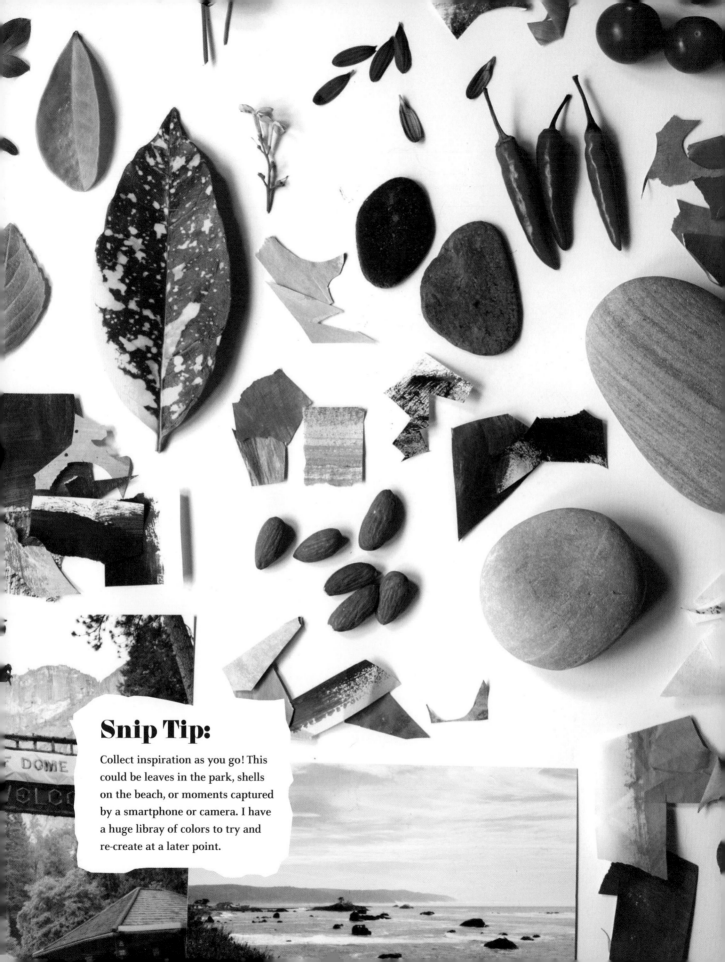

Snip Tip:

Collect inspiration as you go! This could be leaves in the park, shells on the beach, or moments captured by a smartphone or camera. I have a huge libray of colors to try and re-create at a later point.

FINDING INSPIRATION

Inspiration is absolutely everywhere, and will be different for everyone. I'm pretty nostalgic and love to collage fond memories, special moments, and things that look striking or joyful. One of my biggest inspirations has always been nature with all its assortment of colors. Whatever your inspiration is, let it guide you in choosing your color palette.

Certain established rules exist around combining colors, which can be useful, but when I'm making collages I tend to focus on what I want to create and use that as my guide. Nature, for example, has a fabulous way of knowing what works. Bright blue skies, dark imposing sea, gray rough rocks, and orange-yellow sand all work together spectacularly, and can be drawn on without any prior art education or color training—although all of those colors work together by color-training rules.

My only real advice with color is to really look. For example, are all autumn leaves orange and brown? No, they are pink and black and speckled with yellow and orange and a million other colors. My collages aren't just a form of self-expression; they are a documentation, a record of things I've seen and done. So don't feel restricted by your palette. Have fun, experiment, and enjoy combining the options available to you. You'll know what works for you and what doesn't.

Experiment and enjoy the process of looking, and color your world however you want it to look, letting your color palette be guided by a place, object, or experience rather than dictated by any accepted rule of art and design.

STEP-BY-STEP: BASIC COLLAGE

First, let's assume you've chosen what you'd like to collage already. Here, I've used some carnations that caught my eye with their distinct patterns and markings. Set out your paper and take a really good look at what you're about to collage. Consider its scale, size, and general shape.

1. Mix your colors.
Don't be afraid to get messy! Combine lots of different colors that occur in the object or scene you're creating, and experiment with a broad spectrum of colors that you can create.

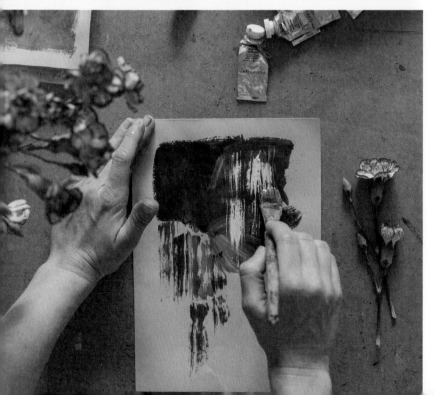

2. Get the paint down.
This is when observation is most important. I arrange my color palette beforehand, but then I like to observe my subject while mixing colors on the page. Take a closer look: are there any distinct markings or tonal differences? You know something is green, but is it more blue- or yellow-green? The colors that you end up with don't have to be exact. In fact, it's usually more exciting if your final color is a bit different than what you were expecting. This is where the magic happens!

3. Start cutting.

Break your object into simple shapes, looking for any distinctive curves or angles. Cut out the simple outlines from your prepared paper and start placing them on your page. I cannot stress this enough: there is no right or wrong way to do this. Cutting is like drawing with scissors instead of a pencil. Each person's interpretation will be a bit different, which is what makes it so great.

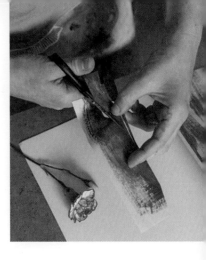

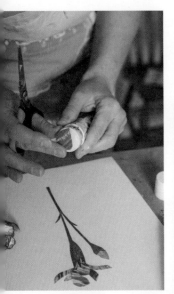

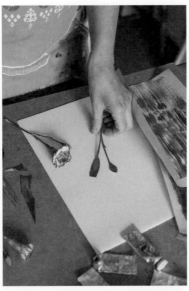

4. Start sticking.

One of the things I love about collage is the simplicity of the shapes you can create. Build your paper layers and move them around the page until you're happy with the way things look. Embrace any little errors as part of the process. Some of my favorite pieces were happy accidents.

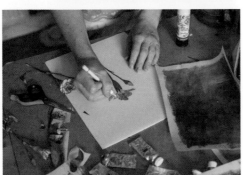

5. Add another medium.

This isn't required, but I love to color and draw on my collaged creations, especially with coloring pencil or pastel. This can provide definition to an object and add more texture to the piece. Take your time, though—it's easy to add more color and texture to a piece, but difficult to take it away.

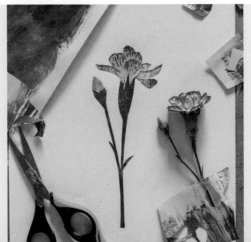

6. The finished piece.

Now is the perfect time to add any other little details or snips. Once those are done, just sit back and enjoy your creation!

COLLAGE THEMES

Now that we've gone over the basic process of creating a collage, we can start looking at specific objects around us to translate into art with cutouts! As always, what you create with your scissors and paper is up to you, but I find that art is most effective when it comes from your life and represents a bit of yourself and what you are passionate about. In this section, I'll teach you the basics of the objects I like to collage—nature, scenes about town, and more— so that you can use them to cut and build your own artwork at home. Ready? Let's see what we can cut!

Snip Tip:

I like to keep a little diary or notebook on me to record anything that catches my eye or inspires me. I quickly make a note before moving on. You could do this with a camera or maybe your phone with a quick snap.

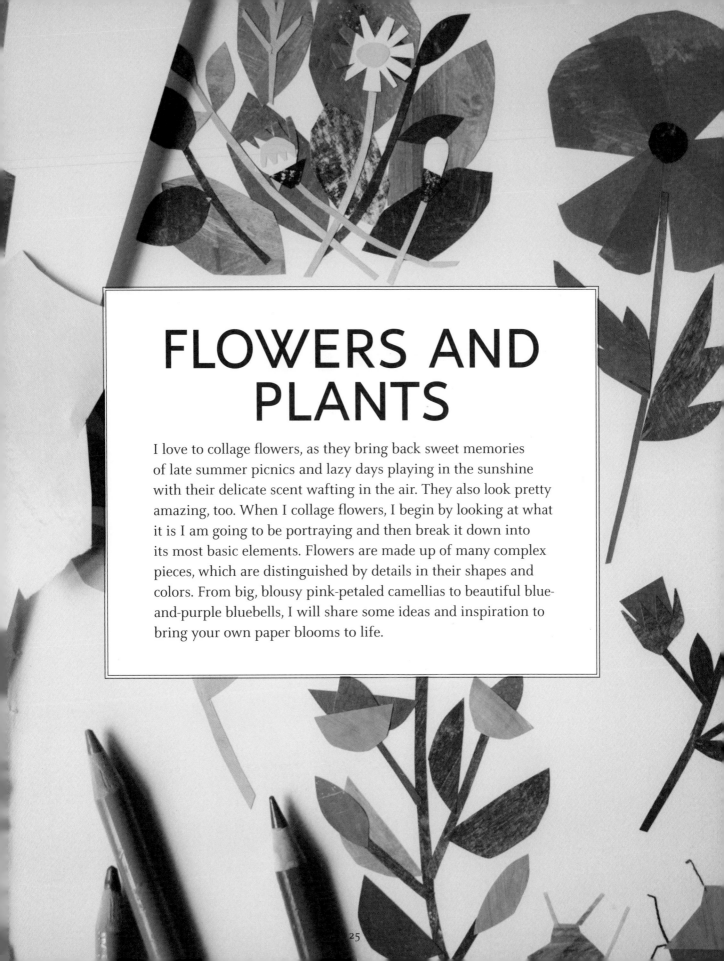

FLOWERS AND PLANTS

I love to collage flowers, as they bring back sweet memories of late summer picnics and lazy days playing in the sunshine with their delicate scent wafting in the air. They also look pretty amazing, too. When I collage flowers, I begin by looking at what it is I am going to be portraying and then break it down into its most basic elements. Flowers are made up of many complex pieces, which are distinguished by details in their shapes and colors. From big, blousy pink-petaled camellias to beautiful blue-and-purple bluebells, I will share some ideas and inspiration to bring your own paper blooms to life.

FLOWERS

One of the first flowers I ever snipped was a big, blousy camellia from my mum's garden. I was instantly drawn to its large, rounded red petals and strong architectural-like stamen. Even if the species differ, the principles for cutting most of my flowers are very similar. Usually, I begin by cutting basic shapes that look like the flower's petals. I then do the same with the stamen and other bits of the plant that stand out. Once this is done, I focus on the details that set one flower's petals apart from another's. There are no hard-and-fast rules here, and sometimes certain bits look too big in relation to another. Before adhering your cutout shapes, play around with their position on the page and cut them into the right shapes.

Basic petal shapes

Stamen

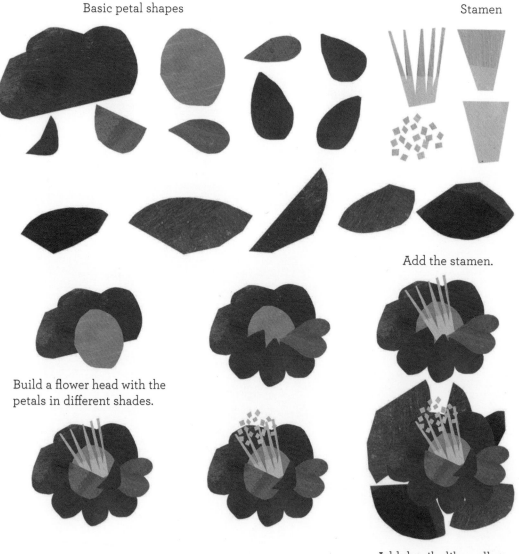

Build a flower head with the petals in different shades.

Add the stamen.

Add details, like pollen, to the ends of stamens.

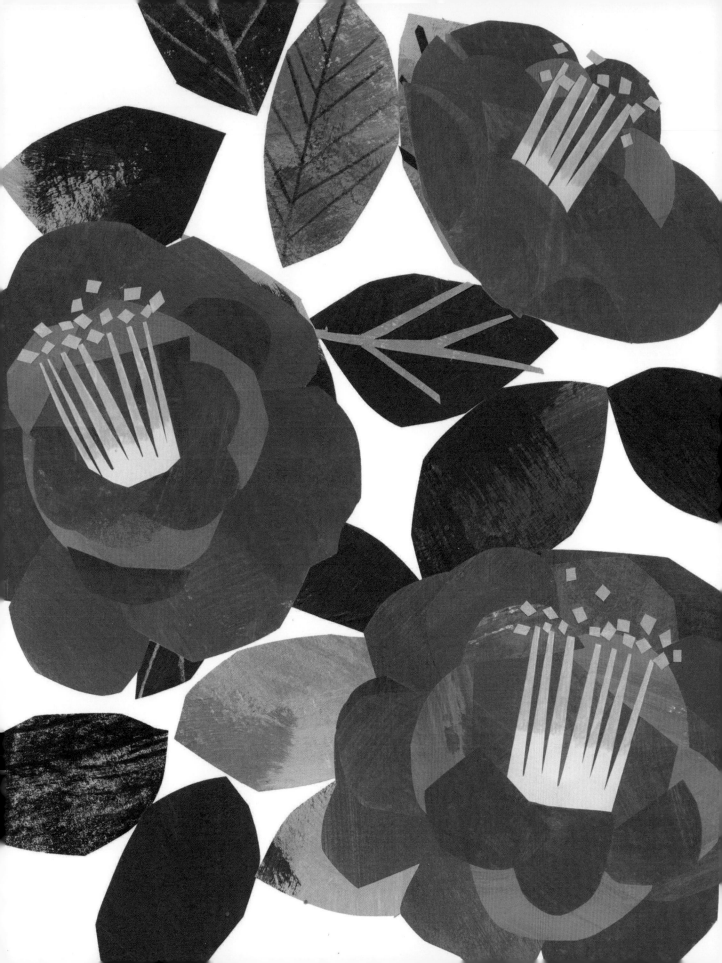

FLOWER ELEMENTS

The wonderful thing about flowers is they all look so different. Here are the elements for a few of my favorites. Play with different color combinations and keep the shapes simple, and you should be able to collage them well. Pansies are up there on my list of favorite flowers. I love their gentle bobbing heads and contrasting pops of yellow and black. They are also made up of distinctive shapes, so they are especially fun to try and interpret. Hydrangeas are a great flower to practice with your painting and coloring. Often their petals have a sort of dip-dyed or ombré effect, meaning that one color seems to gradually blend and turn into another color. I find that coloring the edge of a piece of painted paper with colored pencil or crayon in a contrasting color gets the job done well. Roses and ranunculi can be captured succinctly with the swirl of a pencil in a shade darker than the paper, which expresses the swirl that we see inside of a rose's petals.

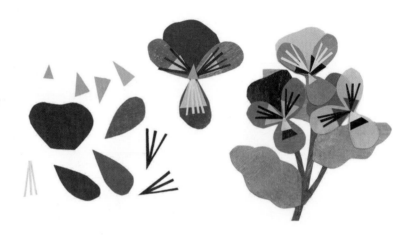

Pansy
Snip triangular shapes slightly smaller in size than the petals. Cut curved, teardrop-shaped pieces for the petals. Triangular shapes at the top give contrasting details.

Bluebell
Cut bell-shaped petals. Follow with triangles in a darker shade of the petal on top for definition (you can also achieve this by using a dash of pencil crayon). Snip a long-curved stem.

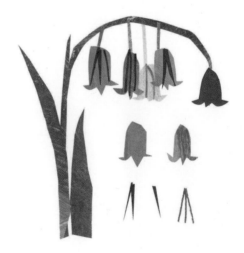

Forget-Me-Not
Cut a simple, blue disc with small triangle shapes to define the petals. Add small, off-white stars with tiny yellow-and-black dots.

WINTER FLOWERS

We think of the latter half of the year as being cold and barren, but you can still find an abundance of flora during autumn and winter. I've included a few seasonal specimens for you to consider using, by applying the same process to them as you did to your spring and summer flowers.

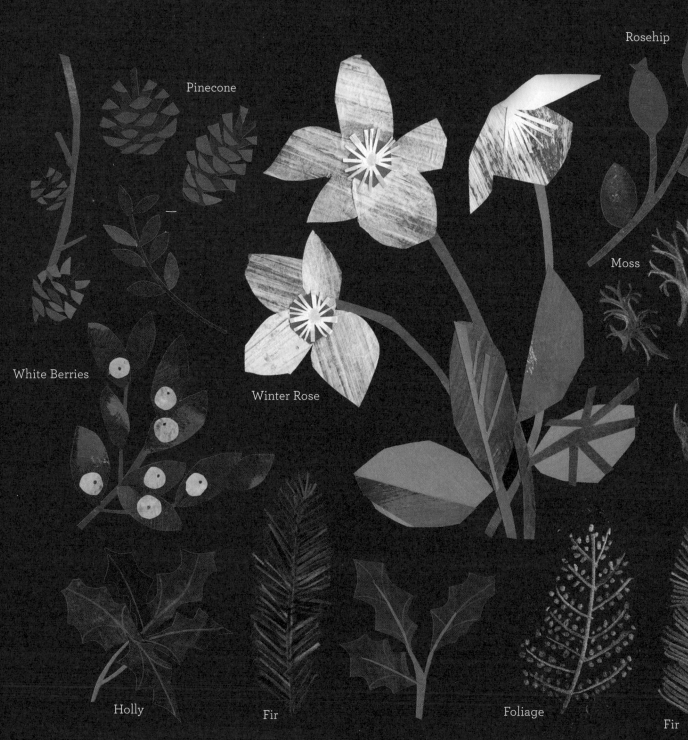

Rosehip

Pinecone

Moss

White Berries

Winter Rose

Holly

Fir

Foliage

Fir

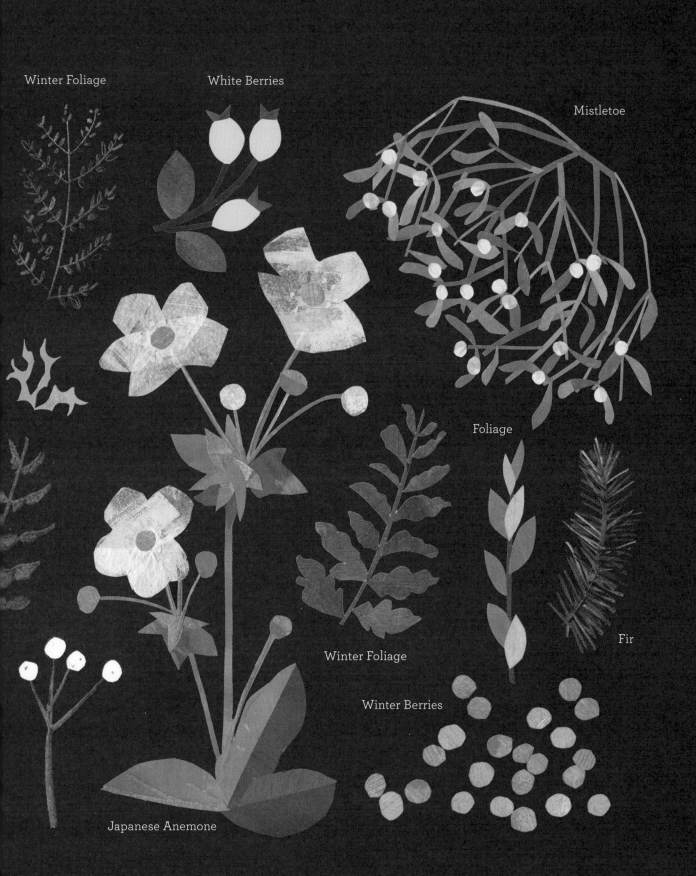

Winter Foliage

White Berries

Mistletoe

Foliage

Fir

Winter Foliage

Winter Berries

Japanese Anemone

LEAVES AND GREENERY

Creating leaves and nonflowering plants is similar to creating flowers and petals. Take your time and really look to see the distinguishing shapes and colors of the different kinds of leaves and plants. Are you seeing them beneath a canopy shading you from the sunlight? Are some a bit nibbled, or maybe old and gnarled? Each of these unique features gives every plant its individuality, identity, and character. I like to use painted tissue paper and splattered textured paper when making leaves. The transparency of the tissue creates lovely colors when the papers are layered. Make sure to start drawing on top of the cutout leaves to create lots of lovely depth and texture.

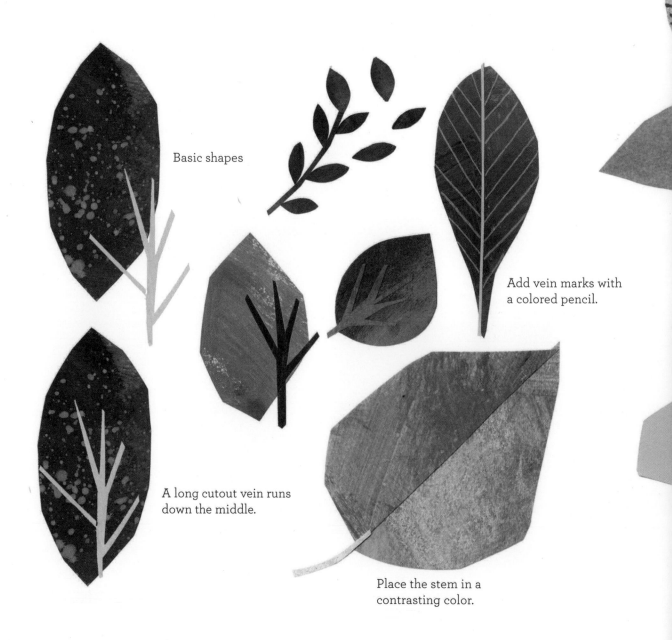

Basic shapes

Add vein marks with a colored pencil.

A long cutout vein runs down the middle.

Place the stem in a contrasting color.

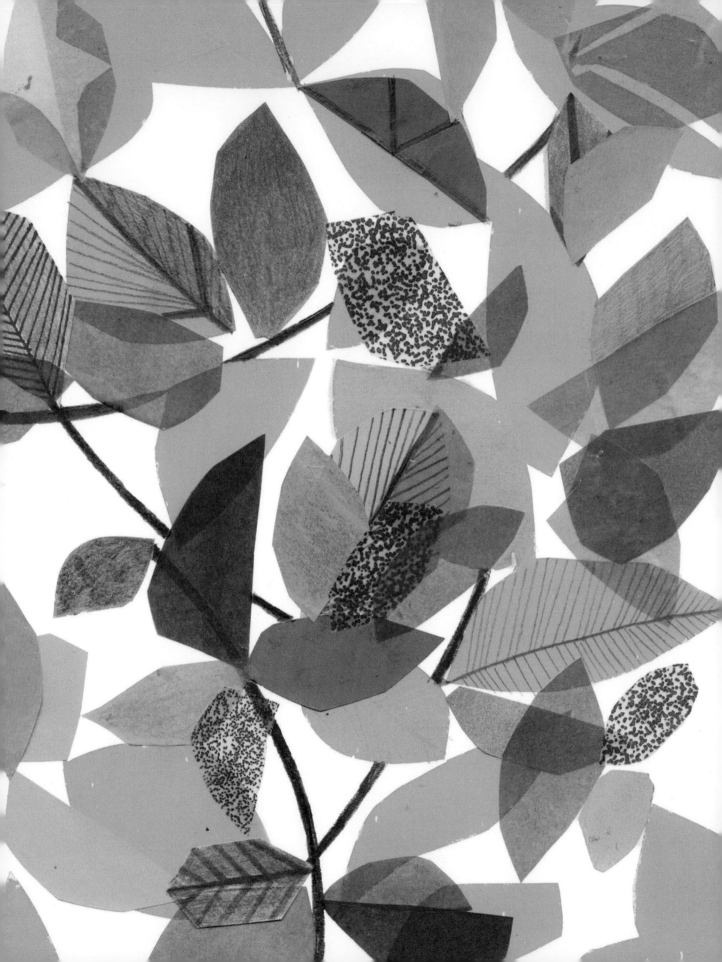

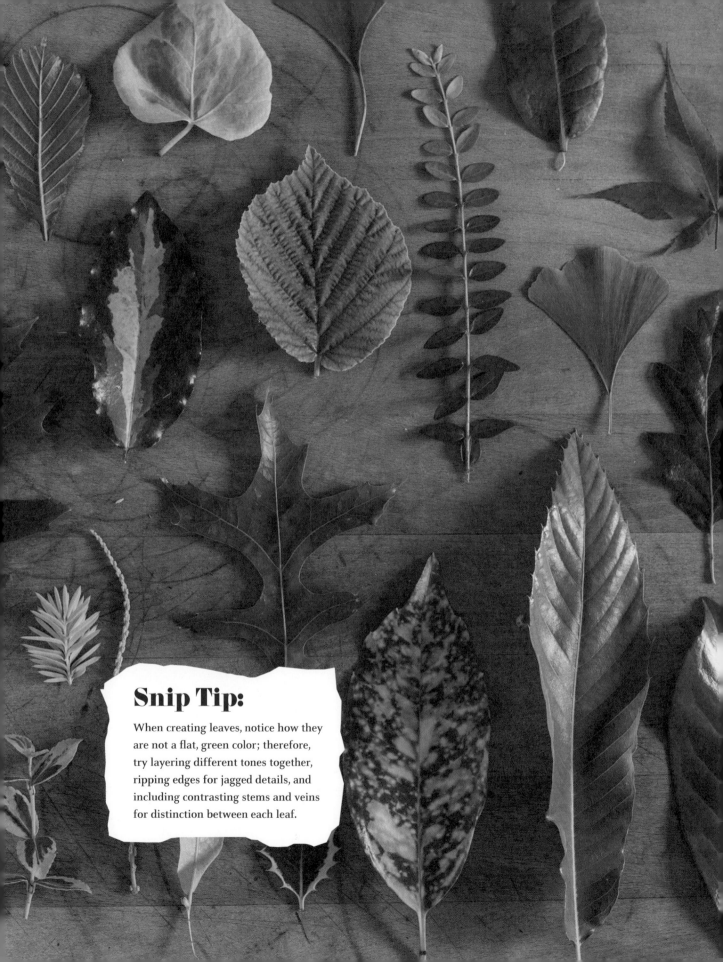

Snip Tip:

When creating leaves, notice how they are not a flat, green color; therefore, try layering different tones together, ripping edges for jagged details, and including contrasting stems and veins for distinction between each leaf.

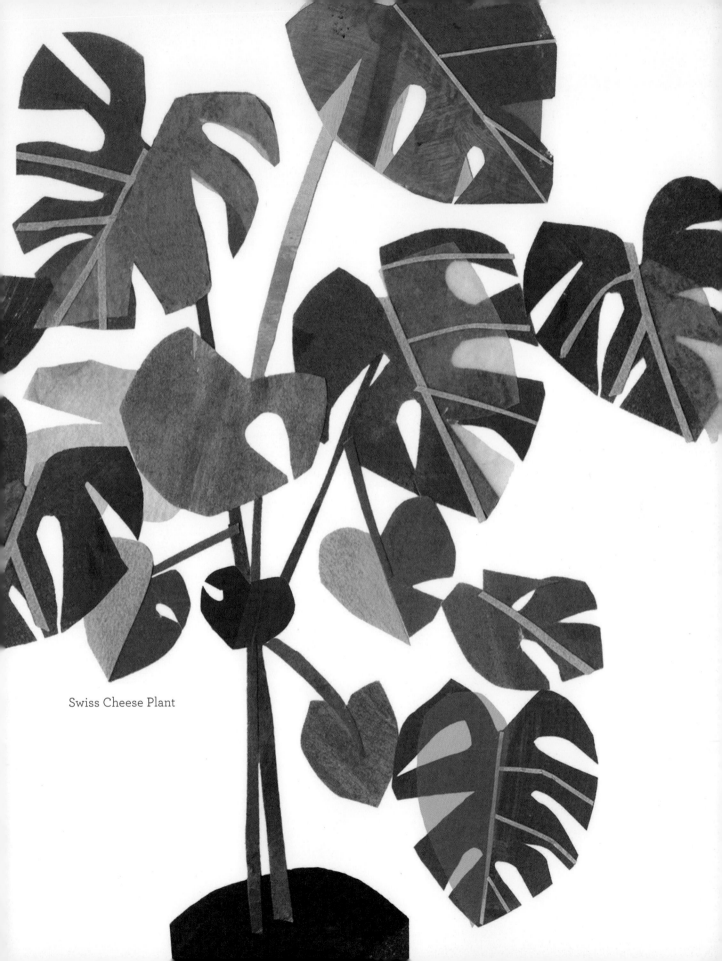

Swiss Cheese Plant

POTTED PLANTS

Here are a few potted plants from my current collection to inspire you. I became obsessed with collecting and collaging my plants when I started dissecting their different shapes and sizes, like the distinct circle leaf shape of a Chinese money plant or the spiky fronds of a dragon tree. If you have potted plants around the house, consider observing them for a moment and making your own collage out of them. Then you can embellish them, adding brightly colored stems or even a unique pot for them to go into using an interesting scrap from your paper collection or a custom-cut leaf. Most importantly, though, keep your collage simple and make the plant the star of the show.

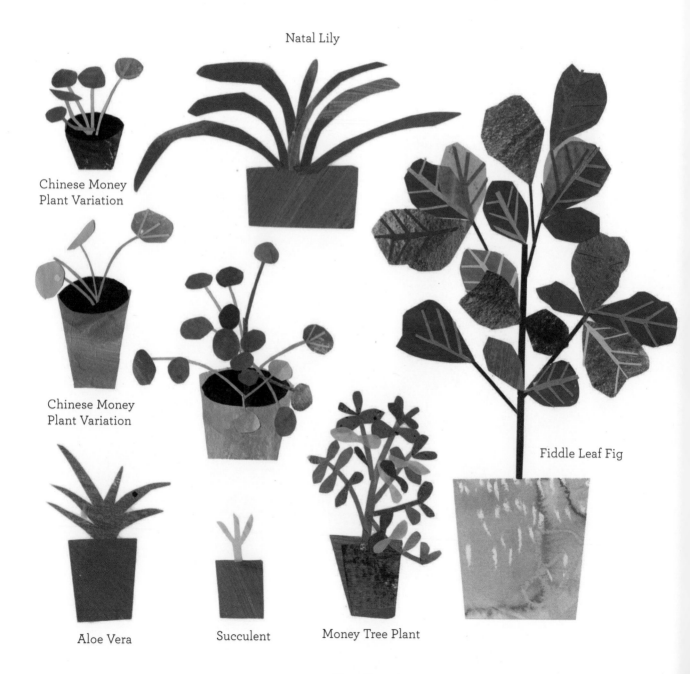

Natal Lily

Chinese Money Plant Variation

Chinese Money Plant Variation

Fiddle Leaf Fig

Aloe Vera

Succulent

Money Tree Plant

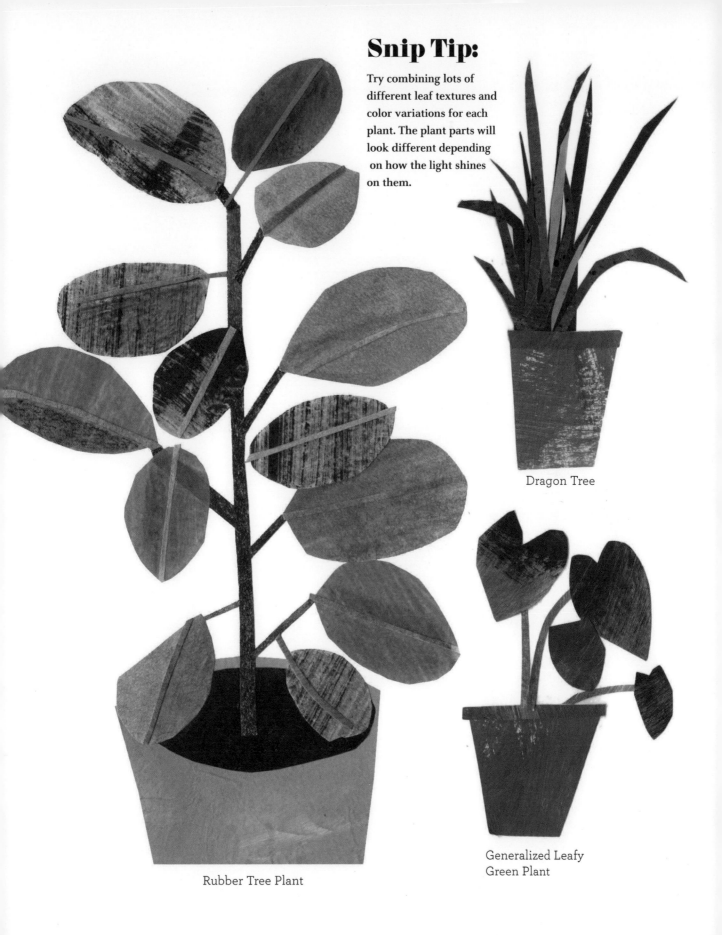

Try combining lots of different leaf textures and color variations for each plant. The plant parts will look different depending on how the light shines on them.

Dragon Tree

Generalized Leafy Green Plant

Rubber Tree Plant

TREES

I have many fond memories of climbing and swinging from trees, as well as picking fruit and ducking under them during rainstorms—a common memory when you grow up in Britain. When I collage trees, I try to make them as individual as the experiences they featured in, from the mass of triangular dark rich fir trees in Canada to the little apple trees in a Somerset orchard. Take advantage of the millions of details provided by trees and tree bark by layering leaves, adding leafy scraps from magazines cut into treetop shapes, and scribbling furiously to put texture in your bark and leaves. For the trunk, I usually use a scrap of paper that has distinct ink paintbrush lines over colored brown pencil or crayon and cut out a rectangular shape with smaller branches coming off it. For realistic wooden texture, you can also use a pencil to take rubbings of a wooden table or bench.

Autumn trees are just as—if not more—beautiful than summer trees. When creating autumn leaves, incorporate some orange-pink leaves and contrasting veins. Coloring over the tops of some of your green collage pieces will give the suggestion of the leaves turning. What may look a bit messy as a solid piece will look absolutely stunning cut into little leaf shapes and layered.

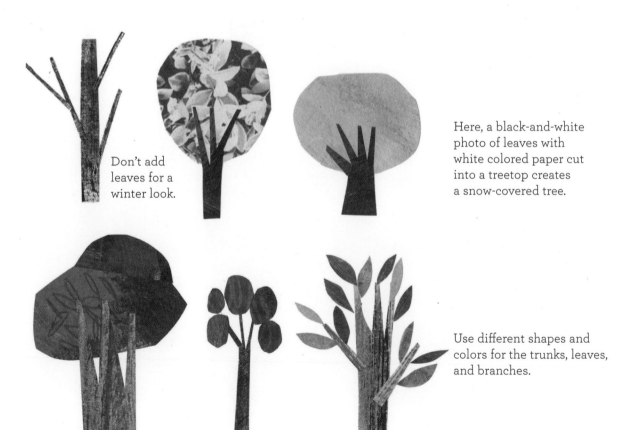

Don't add leaves for a winter look.

Here, a black-and-white photo of leaves with white colored paper cut into a treetop creates a snow-covered tree.

Use different shapes and colors for the trunks, leaves, and branches.

Carrot

VEGGIE VARIATIONS

Here are a few of my favorite veggie variations. Onions look really good when layered on thin, brown tissue pieces. Strawberries come across juicy and delicious by mixing pinks, reds, and oranges, and can be brilliantly captured using some lovely over-painted textured paper with a combination of those colors cut into a simple heart shape. Try adding a bit of pencil crayon for the seeds and little green stalks for the top. I love the pink veins of beetroots and the bright cerise of radishes. Potatoes are full of spots and knobbles, so a few ink splatters on brown papers work really well for them.

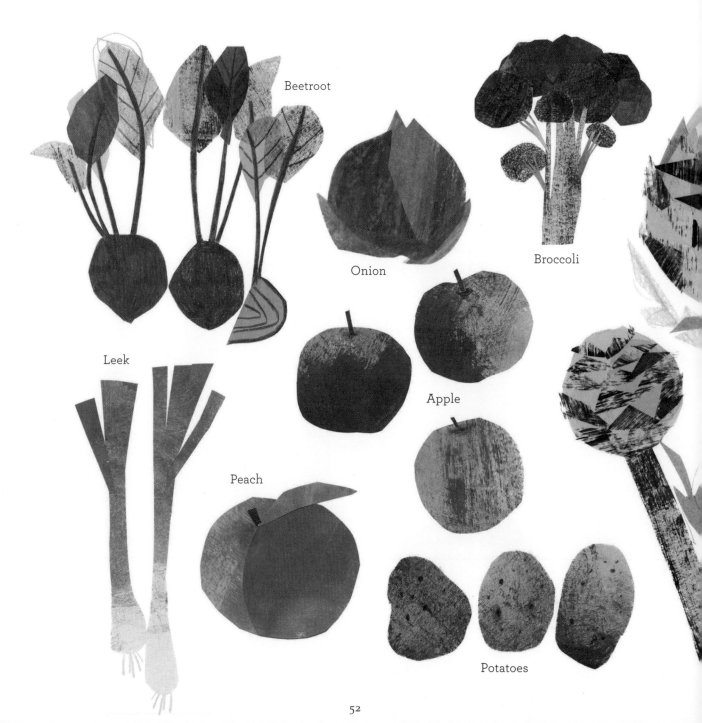

Beetroot

Onion

Broccoli

Leek

Apple

Peach

Potatoes

52

3. Add some black detail. I like to reference real-life butterflies, but also like to add embellishments or change things up if I'm adding a repeating pattern.

4. Throw in a splash of color at the end. There probably aren't many butterflies that look a lot like this one, but blue and orange are a fairly common color combination and really catch the eye.

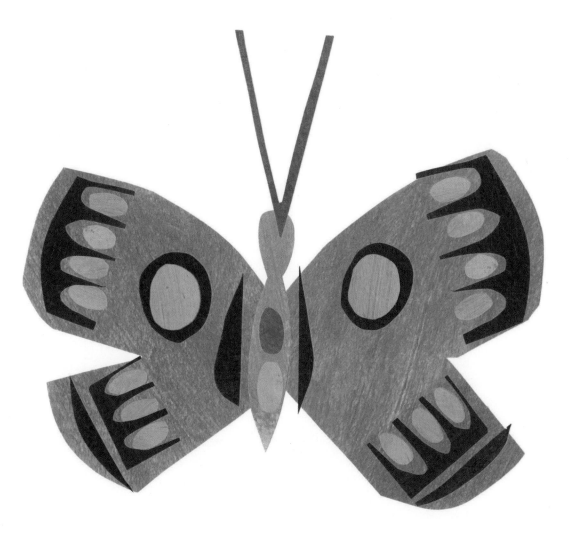

BIRDS

My brother Angus is a birdwatcher, and I have several childhood memories of being brought to birdwatching blinds in the freezing cold and getting shushed into complete silence. The whole thing was lost on me, but Angus loved it, which he still does to this day. He tells me all sorts of different things about their activities and plumage, which inspires my collages.

For a bird's main body and head, I begin with a piece of paper shaped like a sweet potato or lumpy semicircle. I then take one (but up to as many as you'd like, really) more semicircles and begin layering them to create wings and plumage. Feathers let you have fun and create some really interesting textures by using contrasting colors or transparent tissue. Sometimes I like to add in some tail feathers too. Of course, they will need eyes, a couple of feet, and a beak as well. If you're feeling ambitious, you can even have them holding a little worm.

When I create landscapes (see page 111), I like to add the simple shape of a bird soaring into the sky. To do this, you should take the time to research birds with distinct silhouettes and markings—like swallows, which have long, forked tail feathers, or eagles with their wide wingspans and white chests. These little birds are easy to create and add an extra little focal point in your artwork, providing scale and movement.

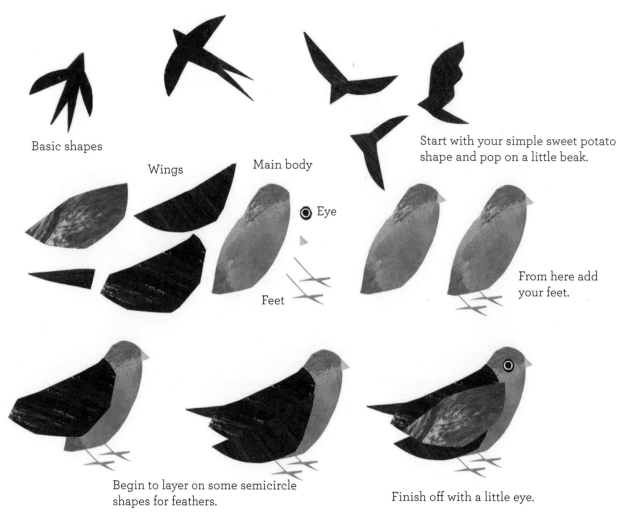

Basic shapes

Start with your simple sweet potato shape and pop on a little beak.

Wings

Main body

Eye

Feet

From here add your feet.

Begin to layer on some semicircle shapes for feathers.

Finish off with a little eye.

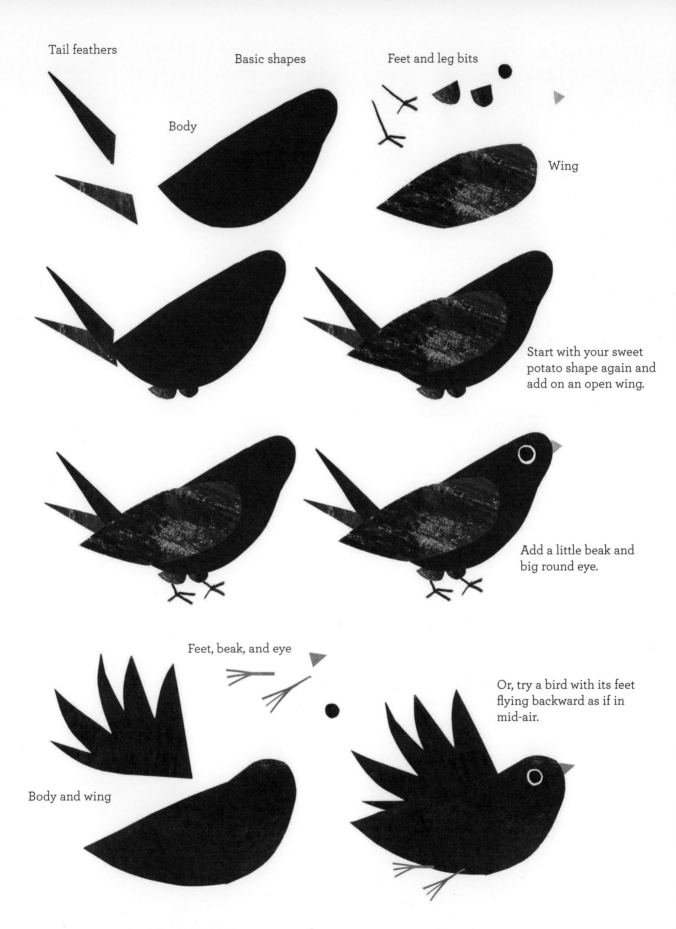

Tail feathers

Basic shapes

Feet and leg bits

Body

Wing

Start with your sweet potato shape again and add on an open wing.

Add a little beak and big round eye.

Feet, beak, and eye

Or, try a bird with its feet flying backward as if in mid-air.

Body and wing

BIRD VARIATIONS

Here are some examples of various birds that illustrate the different ways you can use colored and textured papers to bring shapes and characters to life. By using the aforementioned techniques, layer the different shapes of the bird using various pieces of textured and contrasting papers, highlighting wings or distinctive plumage, such as a robin's red breast or a blackbird's yellow beak. I cut feathers from a bird illustration I found in an old magazine and recycled them for the pigeon and budgie's wings. I then added a puddle of water for the duck and blackbird to splash around in.

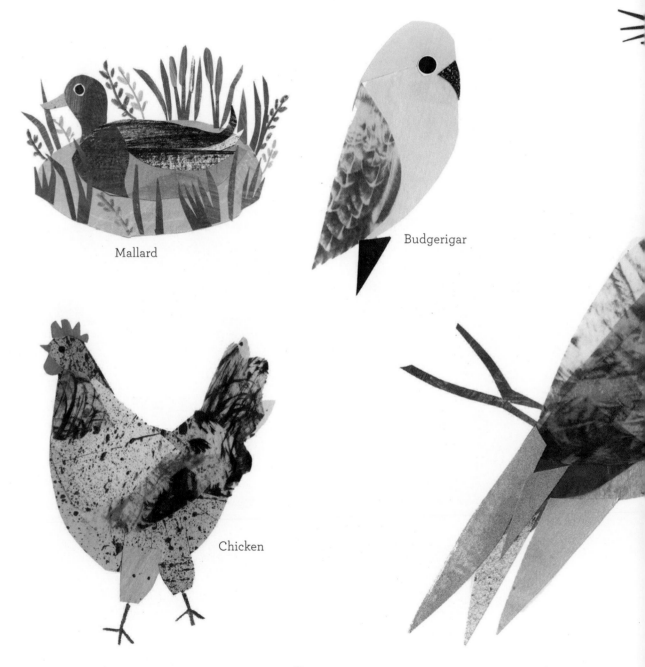

Mallard

Budgerigar

Chicken

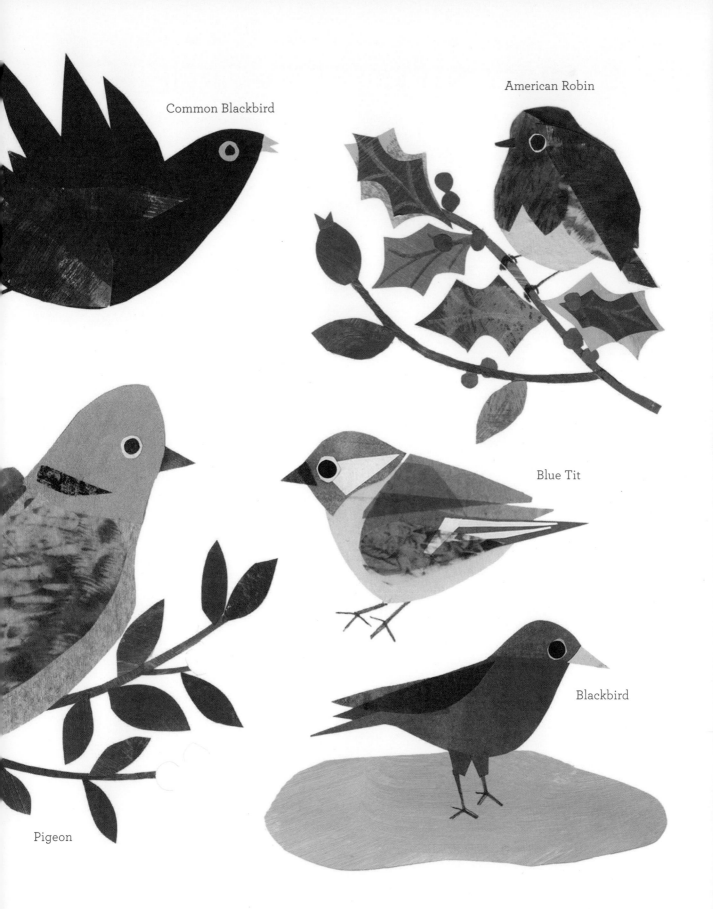

Common Blackbird

American Robin

Blue Tit

Blackbird

Pigeon

STEP-BY-STEP: FESTIVE ROBIN

Robins are go-to birds for me. They are easy to cut, and their little red breasts make them super distinctive. Apply theses shapes to lots of different birds and you'll have a full menagerie in no time!

Basic shapes

Chest

Wings

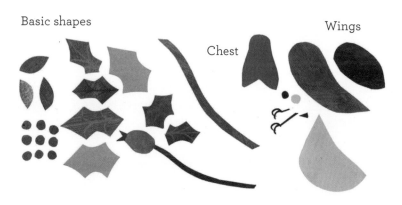

1. Begin with a little branch for the robin to sit on. Make it large enough to accommodate the plump little bird and slightly curved, like you would find naturally in the outdoors. It helps to use a few different textured greens for festive foliage, like sprigs of spiky holly and a few vibrant berries.

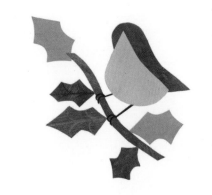

2. Snip a sweet potato shape of brown for our robin's back and a generous semicircle of lighter brown or gray for its belly. Cut out some spindly black legs for it to clutch onto the branch.

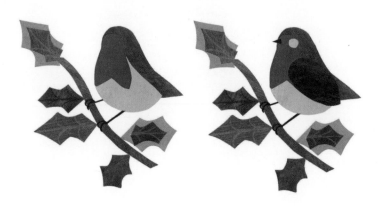

3. With the robin's main body in place, add its iconic red breast. (I find it helps to think of the shape you're cutting as the top of a Russian nesting doll.) Then, using a darker brown to set it apart, cut a fat, little wing shape out to match its cute plump tummy. End with the white circle for the eye.

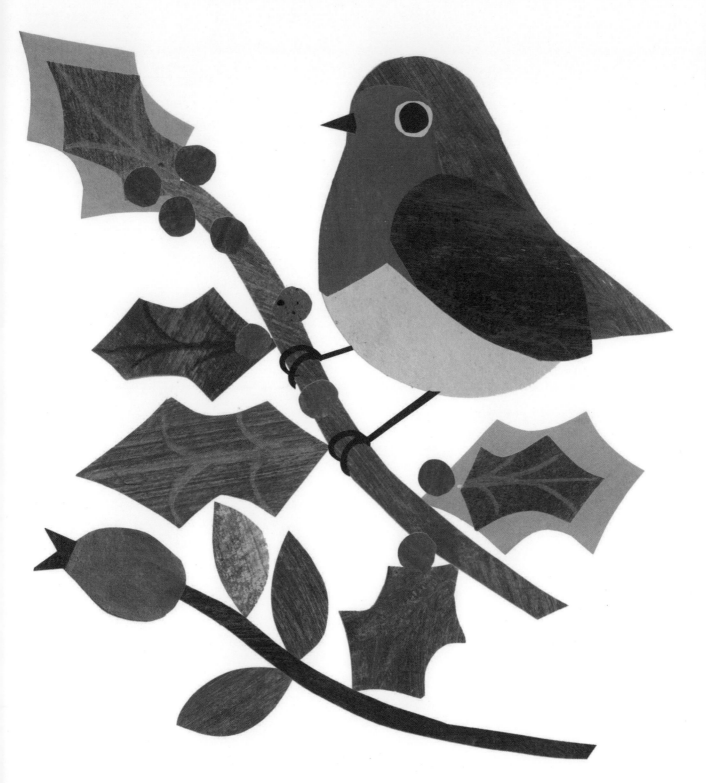

4. Add the finishing touches: a big black pupil for the eye, some pencil or crayon details in the leaves, and maybe a small stem of rosebud as a last little festive flourish.

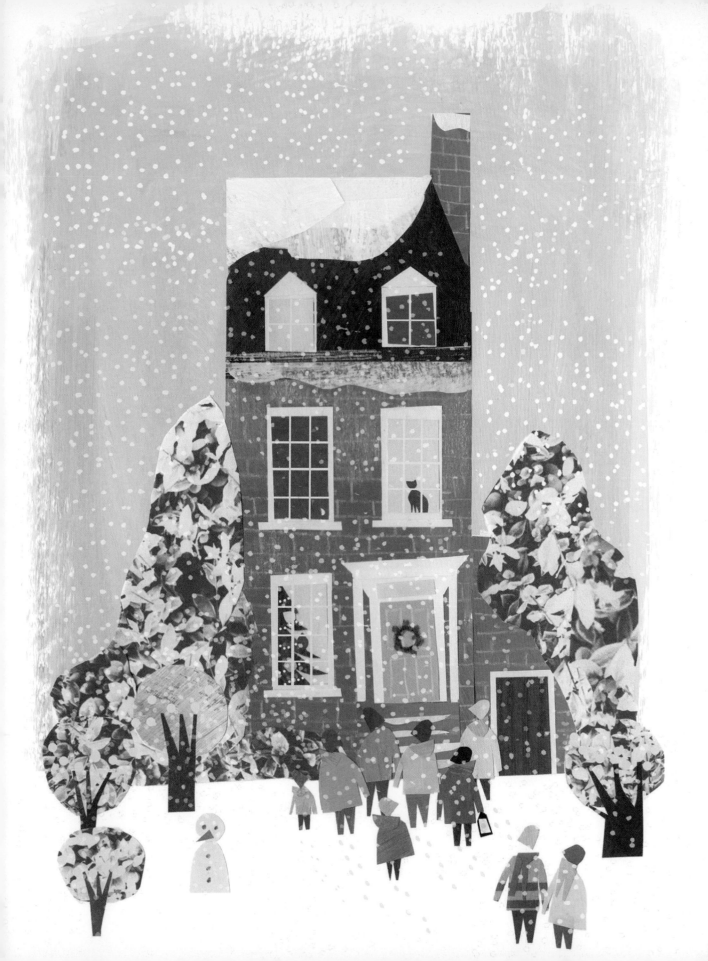

STEP-BY-STEP: CHRISTMAS HOUSE

I was lucky to grow up in a big family, and the holiday season was always a magical time. Everyone and everything seemed to glow with a festive warmth while a tree twinkled in the window. Let's try to embody that heartwarming feeling in a beautiful collage.

1. Start with a painted gray base as the background. That gives a sense of a dark, cold winter afternoon. I painted mine with some gouache, mixing the tiniest bit of black with some white to achieve a bit of texture in the sky rather than a solid gray color. Using the terra-cotta paper included with this book (see page 152), cut a large rectangle, a smaller rectangle, and a tiny rectangle, all of which you can fill in with brickwork lines using a colored pencil. These are your house, your side shed, and your chimney.

2. Place your medium-size rectangle next to your large one to give your house a shed. Then cut out a black square and add it on top of your house. Use white colored pencil to add tiles to it, and it's your roof! Place your chimney on the corner, giving your roof a slight slant.

3. Cut out long, thin strips of white paper and use these to create the door and window frames, and the pillars. Add in blue and yellow squares for the windows, and use a colored pencil or paint to add the thin lines of the interior frames.

4. For a wintry feel, add some small curved shapes of white paper to the roof and the chimney, to add snow.

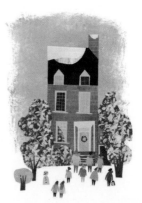

5. Next, the trees. Using the black-and-white leafy paper included with this book, cut out some leafy tree shapes. Then cut out some thin, forked pieces of brown paper for the trunks. Put these around the house, leaving space in front for the carol singers. In the window, I put half of the shape of a Christmas tree, which is easily cut with a sharp crafting knife. Just make sure to draw the window frame on it after you put down the tree!

6. With the main shape and wintry foliage of the house done, its time to add some festive details. A simple snowman in the front yard adds a lot of character, as do adding baubles to the tree or a simple wreath in front. Finally, add your carolers, cutting out a bright coat, hat, and pants shapes using different-colored paper. It's okay if you can't see their faces; people usually look like astronauts when they're bundled up in the snow!

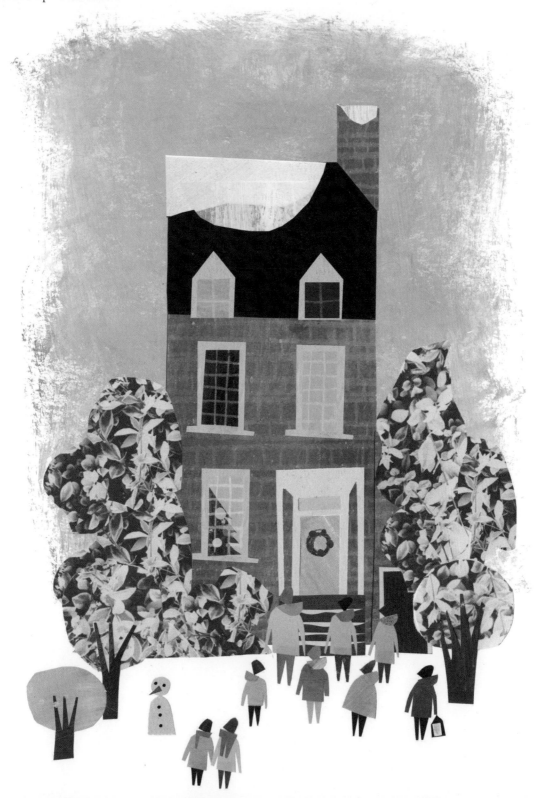

BUILDINGS

Some of your artworks will call for buildings that aren't homes, of course—maybe a skyscraper in the distance or beach huts on the shore. For these nonresidential buildings, just take the previous method and simplify, remove some of the details from the exterior of the house, and focus on the new shapes of the buildings you're trying to re-create.

Now is also the perfect time to dive into your paper scraps and see what pops out. I love to play with contrasting textures for buildings shining on the horizon. You can use simple geometric patterns and pencil marks that create the suggestion of doors or windows like I've done here with this sprawling scene of Canary Wharf in London.

Adding in a little bit of plant life can also help create scale and context. Trees will instantly turn a line of patterned rectangles into a business district or town square, and big stately trees can host wonderful treehouses for little adventurers.

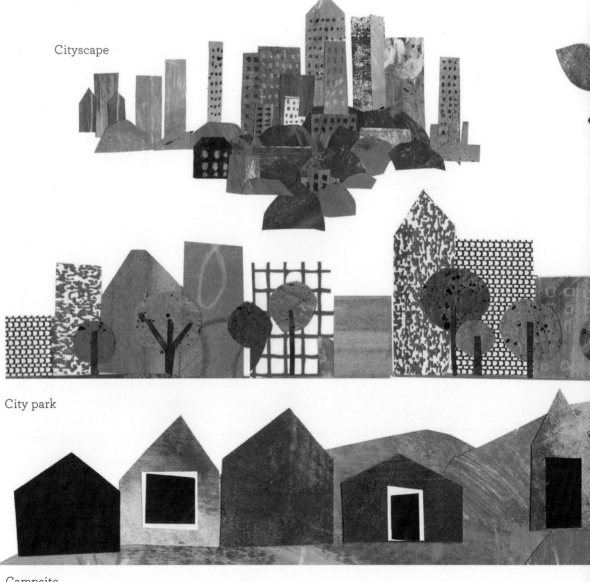

Cityscape

City park

Campsite

Snip Tip:

Make the most of your paper scraps. Leaf through old newspapers and magazines to find awesome textures for buildings and skyscrapers.

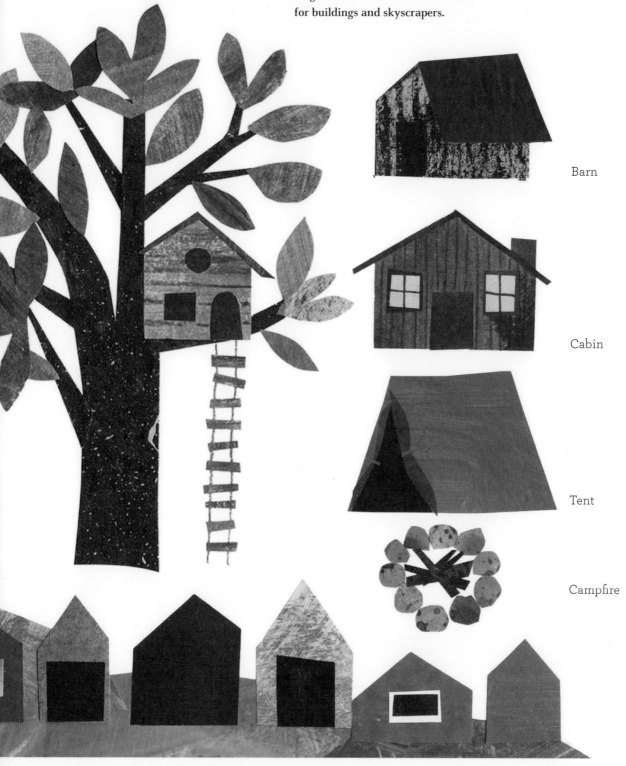

Barn

Cabin

Tent

Campfire

HOUSEHOLD OBJECTS

I come from a family of treasure hunters, and therefore grew up believing a house was not a home without all the stuff that goes into it. But while my family collected and inherited all sorts of unique and beautiful furniture and household items, there are a few things that you will find in pretty much every home, even if they don't all look the same on the outside.

Do you have a favorite mug for breakfast in the morning? A bowl or dish that comes out every holiday? A teapot that's dusted off when friends or family are around? Think about these artifacts when creating collages of home. These are the details that will make your artwork unique and personal to you. Conjure up those old memories and consider them when collaging a home scene. Here is a tiny snapshot of some of the things you might find in my home, made with simple shapes.

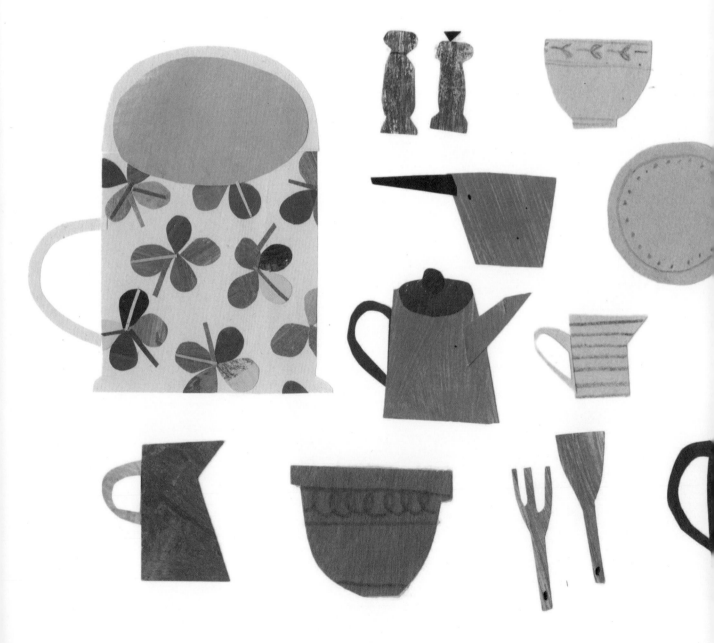

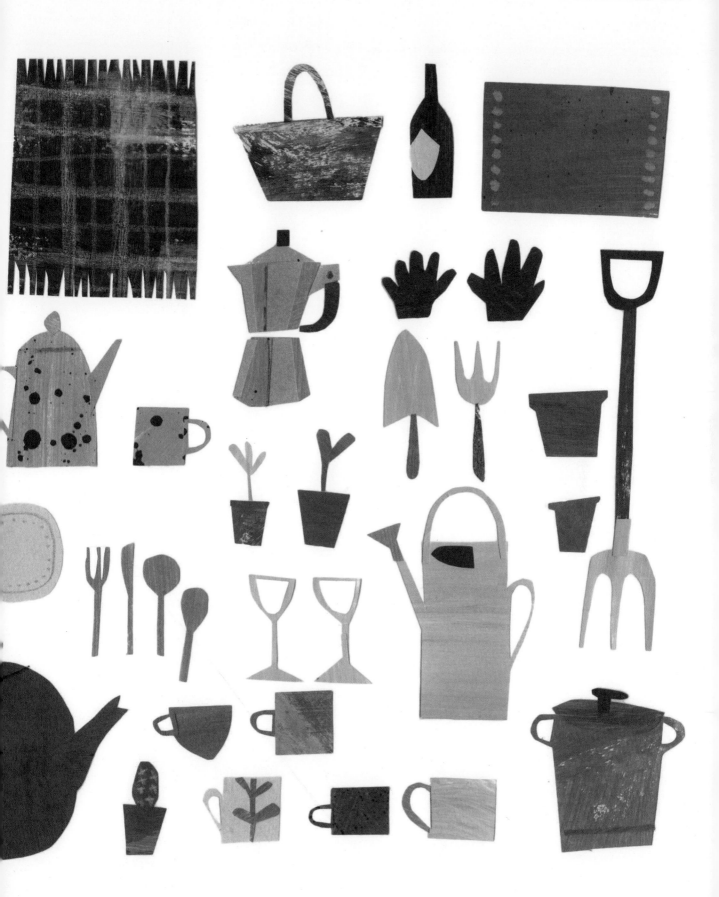

THINGS AROUND THE HOUSE

These can all be created using small snips of paper or interesting scraps (especially my colorful mugs, of which I have more than you can imagine). If you're rendering something larger, just scale up the same general shape.

Breakfast remains unbeaten as my favorite meal of the day. And I love to use little bits of vintage crockery and tableware I've accumulated over the years. I especially love it in spring, when the mornings are brighter and there's a nice vase of fresh flowers on my table. Why not pop some of the elements together like I've done here and create some scenes of your own favorite moments at home? I love candlelit festive winter meals with lots of red wine and plenty of seasonal flowers, crackers, and sprouts.

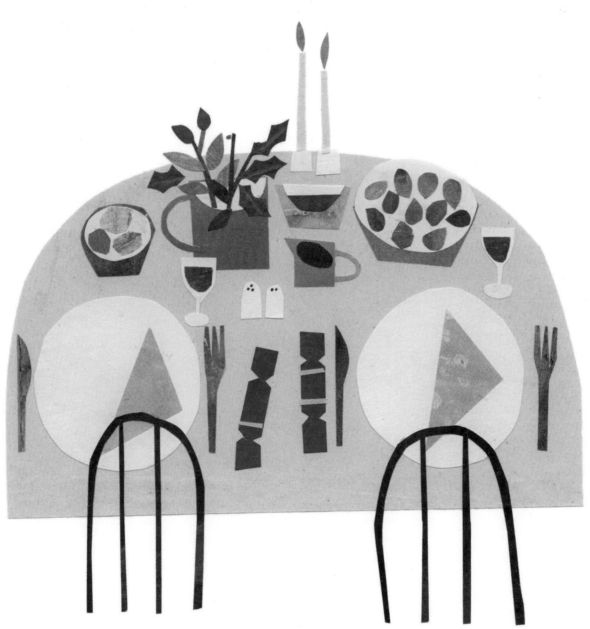

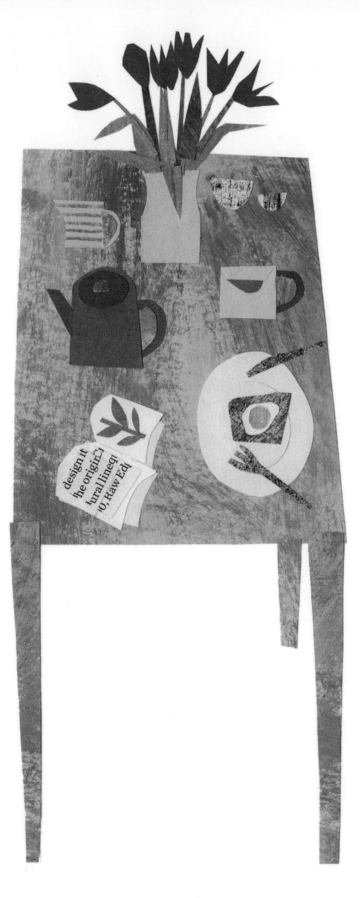

design it
the origin[]
tural line[]
[]0, Raw Edg[]

Snip Tip:

Don't worry if the paper pieces end up looking a bit wobbly; if in doubt, keep the outline shape simple and embellish with a simple cutout decoration, a bit of pencil crayon, or nothing at all!

STEP-BY-STEP: BREAKFAST TABLE

Breakfast is my favorite meal. It's fun to share with people—discussing your plans for the day when anything feels possible—but equally nice alone, sifting through a good garden or design mag with a pot of tea. Here, I re-created a typical scene from a typical morning. Yours will probably be different, so feel free to include some of these things that make it unique to you!

1. Start by creating a table with small rectangles of golden-brown paper. Using a bit of bird's-eye view gives you space to add elements. Then apply two legs in a matching color for the front—I stuck a tiny bit of leg at the back, too, to create perspective.

2. Following the same process as the table, use a slight bird's-eye view to create your chair.

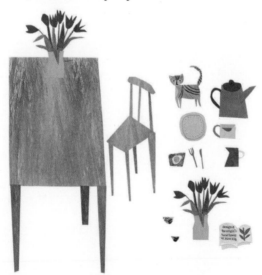

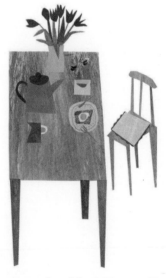

3. Next, start to think about what you might find on a breakfast table. You'll always find fresh-cut flowers on our kitchen table any time of the day, so I cut out some simple tulip heads that add a bit of light color to the table.

4. The main event—breakfast! Use our Household Objects spread (see pages 80–81) to find some items you might want on your table. Cut simple shapes for the mug and teapot. Since we're looking down on the table, we can snip a poached egg straight on. A little cushion on your chair is a nice touch.

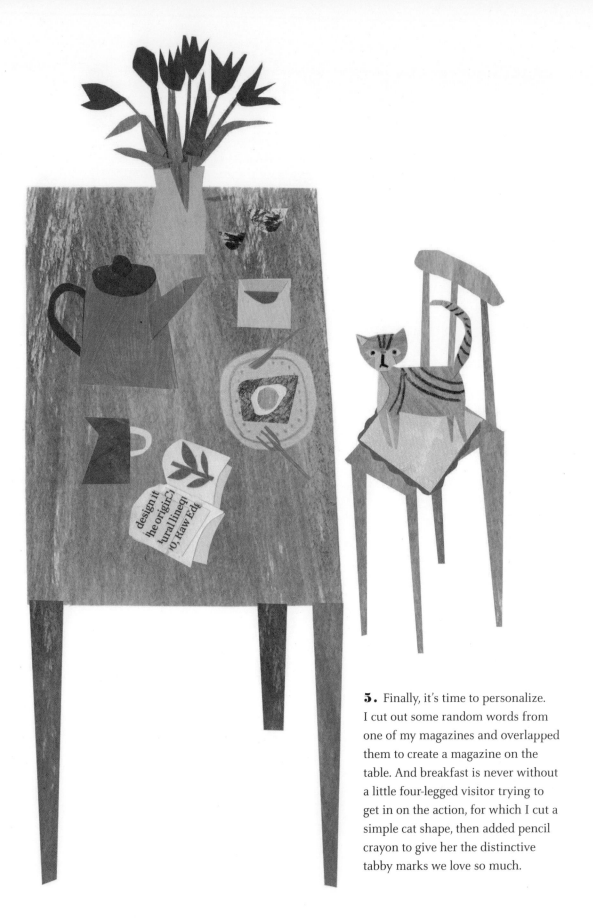

5. Finally, it's time to personalize. I cut out some random words from one of my magazines and overlapped them to create a magazine on the table. And breakfast is never without a little four-legged visitor trying to get in on the action, for which I cut a simple cat shape, then added pencil crayon to give her the distinctive tabby marks we love so much.

THINGS IN CUPS

Having snipped a few basic things, and with an arsenal of inspiration under our belts, let's begin applying these techniques to some different projects! Nothing is more charming than things in adorable cups! My mom has always been an avid gardener, and I was extremely lucky to grow up surrounded by big, beautiful framing devices, from baskets heavy with head-bobbing pansies to bowls on the windowsill full of herbs and wildflowers. Come summertime, you were hard-pressed to find a kitchen container in our house not filled with some assortment of glorious foliage.

These little collaged cups keep the magic going year-round. They're easy to create, too—just use your favorite cup or jug and pop something in it that you love. It doesn't have to be flowers—it could be a plant, mint tea, or a cactus. As long as you're collaging flowers in mugs, why not try a conventional vase as well? Use the same concept as you did with the mugs, but take it to the next step and add in a few more details. ·

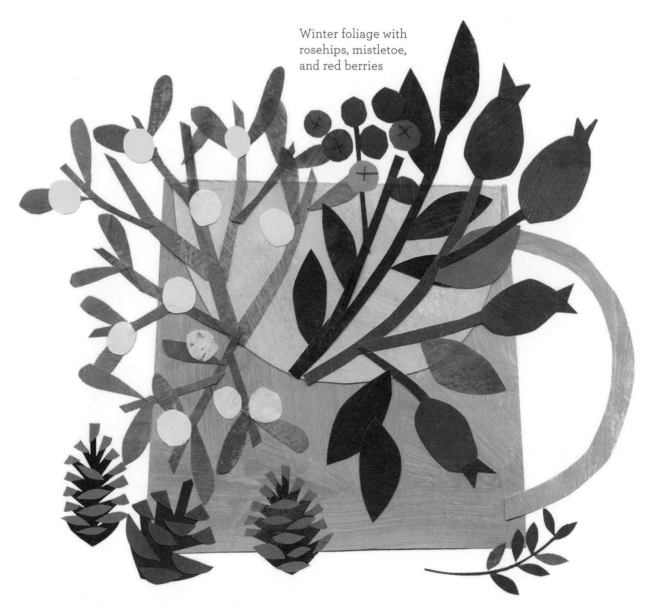

Winter foliage with rosehips, mistletoe, and red berries

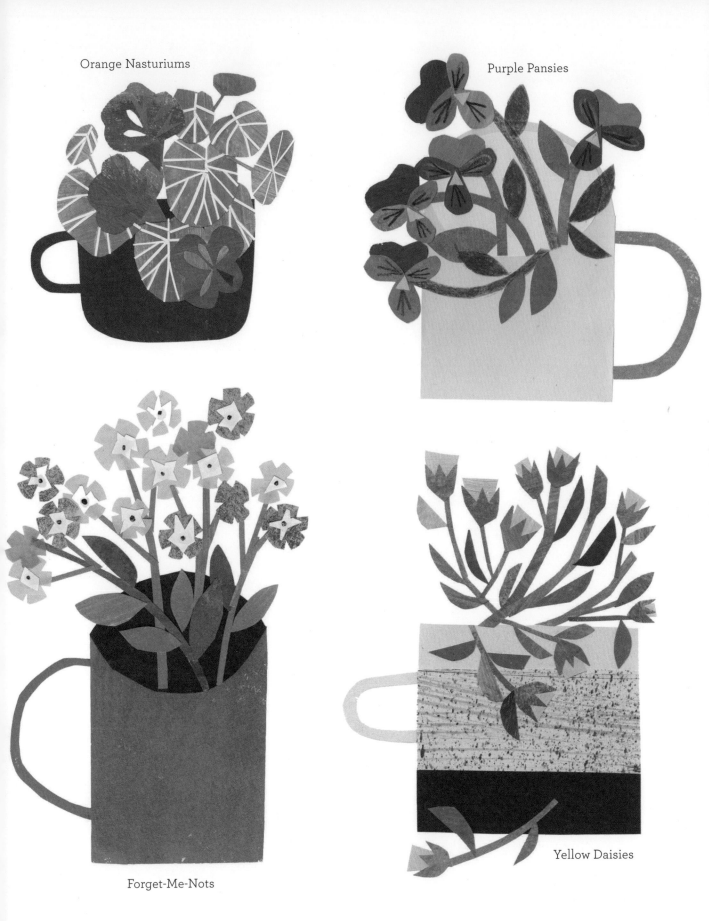

Orange Nasturiums

Purple Pansies

Forget-Me-Nots

Yellow Daisies

STEP-BY-STEP: A JUG OF FLOWERS

My mom is the master of floral arrangements in tiny jugs. I'm not quite on her level, but have found plenty of enjoyment creating my own paper versions.

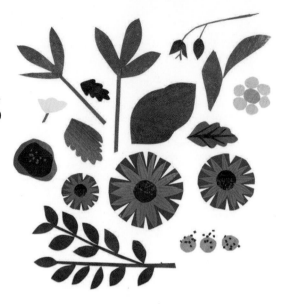

1. Decide on your vessel. I've created a little blue jug inspired by a vintage jug I picked up at one of my many trips to the seaside. You could use a block color and apply simple decoration, so that the flowers are the stars of the show here.

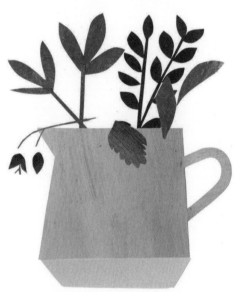

2. Using a few different shades of green, snip out some leaves and separate bits of foliage. Adding different shapes and tones helps create depth. I've arranged them much like I would an actual bunch of flowers, placing the taller ones at the back.

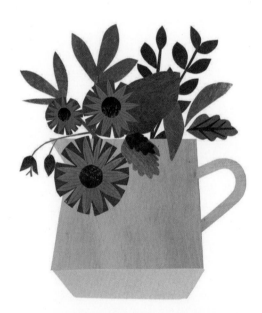

3. A favorite color combo of mine is blue, purple, and green. Cut out large paper circles and smaller ones of a contrasting shade to stick inside each flower's body. Then snip out tiny long triangles all the way around to make the petals, adding pencil detail if you like. Pop in a bit of supporting foliage to blend in any gaps.

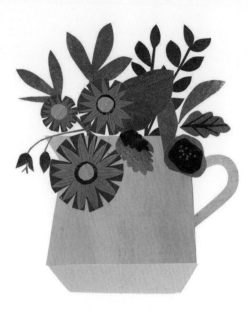

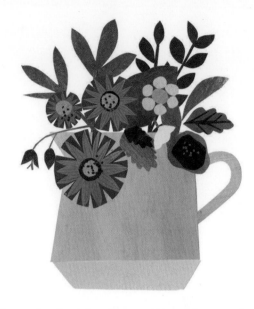

4. Often things look more pleasing in odd numbers, so I've added in three big statement flowers that look good against the simple blue jug. I've also added details of orange to the main purple daises and an additional purple flower on the right to balance the collage.

5. For finishing touches, toss in another couple of simple white daises, which look great against the block-like green leaf and helps break it up. Then add some little black dots onto the daisies' central orange disks.

Ta-da! A jug full of summer flowers that will last all year. Use your own treasured vessel and create a floral arrangement out of some of your favorite flowers.

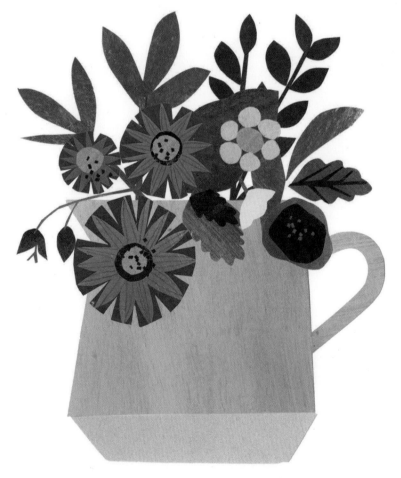

PEOPLE

While birds, butterflies, and teakettles add plenty of character to a collage, people will complete a landscape wonderfully. I find that collages don't have to be detailed, either—just a few cuts is all it takes to give a suggestion of character. I usually start with a basic round head shape, an elongated semicircle for the body, and a squared-off triangle for the legs using colorful paper for clothing and skin. Then I consider hair, or perhaps a little hat. These are things that will make each character unique. Cut out little arms and move the pieces of the body around, and experiment with how they look next to each other—are they in proportion? If your characters are in motion, snip a little bend in the leg to suggest walking, or add an arm in the air waving.

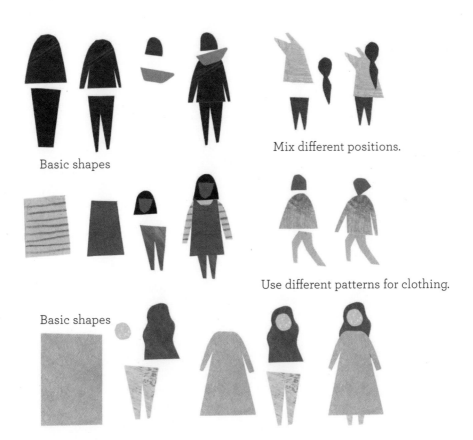

Basic shapes

Mix different positions.

Use different patterns for clothing.

Basic shapes

PEOPLE VARIATIONS

Little people aren't the only way to bring a scene to life. Pets—like dogs and cats—make great supporting characters in collages. Why not get your characters doing a few different activities? Take them walking, climbing, or cycling—whatever it is you like to do in your spare time!

Snip Tip:

Do not over complicate your characters or animals. My interpretations can be crude to say the least, so keep the shapes simple and add in a few defining features like markings, patterns, or accessories to help tell the story.

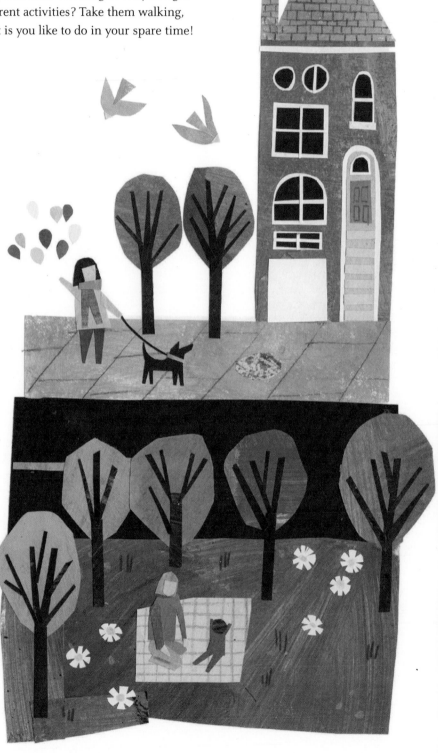

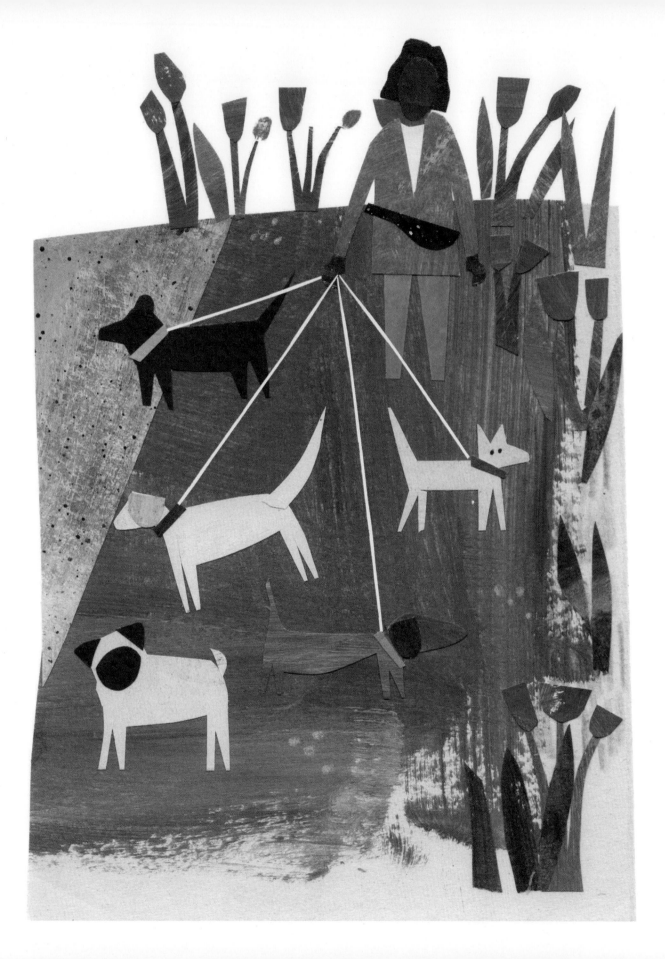

STEP-BY-STEP: A DOG PARK

I don't have a dog myself, but I do get so much pleasure from observing the dogs and their owners in all our local parks. They bound with careless joy, and come in every variety. One of my favorite things to notice are the dog walkers, being tugged along by all sizes and breeds of dogs. Here, I tried to give you a step-by-step of collaging one.

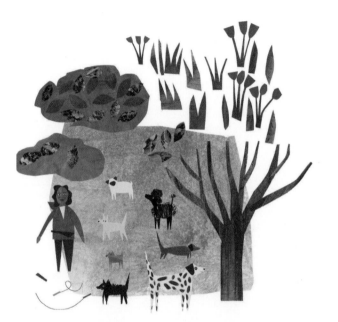

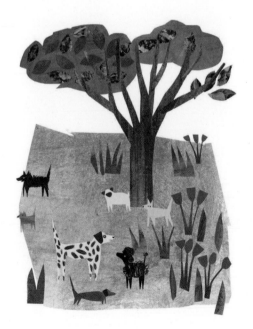

1. Since this scene is set in a park, let's start with snipping a squarish piece of grassy-green paper, along with a few flowers and some grass in a darker color. Go for simple shapes; we want to make the dogs the main focal point. I included some tall green stems in different colors for the blades of grass and bright red semicircles for the tulip heads. Finally, cut some big green cloud shapes for the leaves for the trees.

2. Now, on to the main event—the dogs! You can add any breeds or types of dogs you like to this collage; they all have similar body shapes that can be summed up with a rectangle, two legs on each end, an arrow-shaped head with ears, and a tail. But feel free to go wild and make your collage feature a Dalmatian or a poodle!

LETTERING AND PATTERNS

Lettering artwork and patterns is a perfect way to personalize a collage or other gift. In the following pages, I created a series of floral wildflower-themed letters. Do these look tricky? I promise you they're super easy.

FLORAL LETTERING

For floral letters, start by using a pencil to sketch out the letter of the word you would like to write. Then cut out a few long stems, using different shades of green throughout. It's good to get some contrast in the colors here to create depth in the letter and really bring it to life.

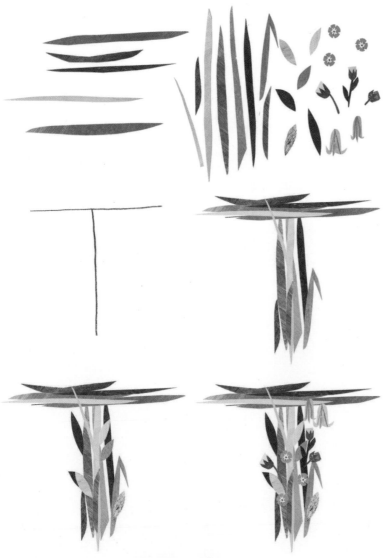

Once you have the foundation of the letter created, add in some leaves of varying shapes and sizes. Again, play with different shades of green to create depth and contrast. By now, your letter should really be taking shape. Now you can start thinking about what flowers you may want to add. Wildflowers were the obvious choice for me because of the way they weave in and out of other plants and flowers, making a beautiful mess.

Think about balance in your letter. Letters often look stronger when most of the elements and different colors are evenly spread out. Take some time and have fun moving the pieces around the page before you commit to adhering them.

Snip Tip:

Like creating a jug, bunch, or vessel of flowers, think about layering foliage delicately. Mixing different greens in a balanced and thoughtful way avoids a clump of similar colors.

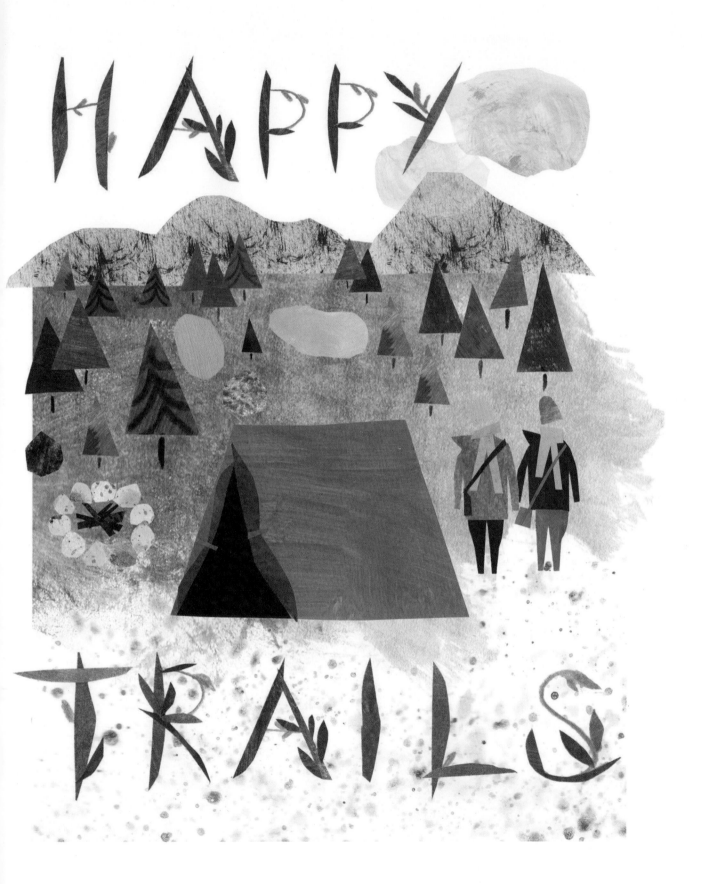

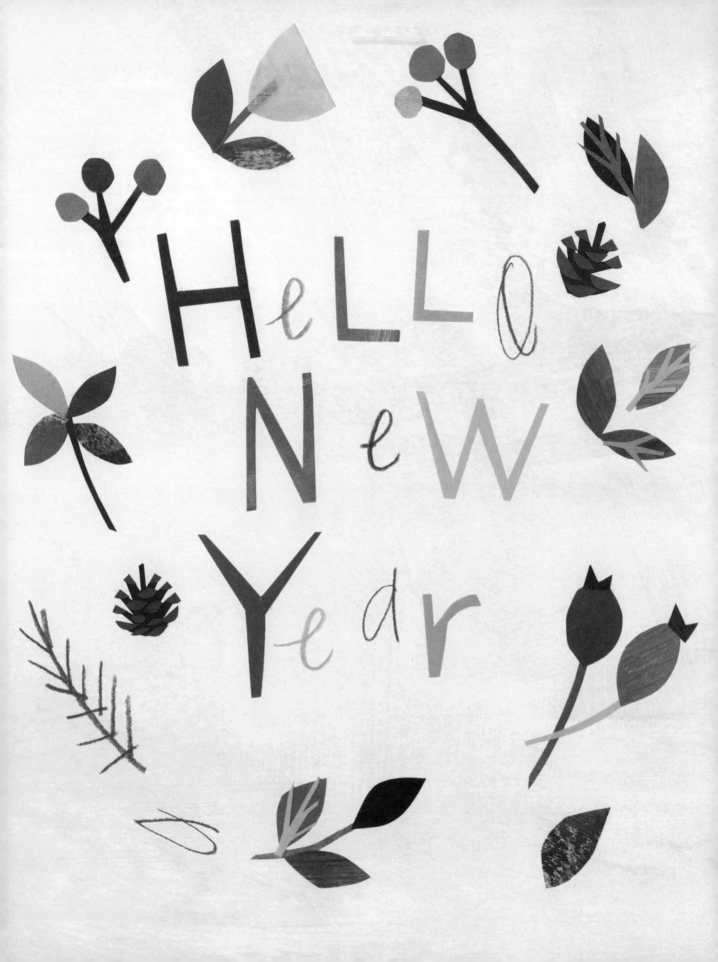

4. Finally, cut and add your tropical flowers. Since we've used so much green, you can keep the shapes of these flowers simple so long as the color is bold. Having them ascend from the bottom of the collage makes them look as though they're rising up through the undergrowth. Putting a few darker leaves on top of the whole thing only adds to the shadowy, exotic feeling of the jungle.

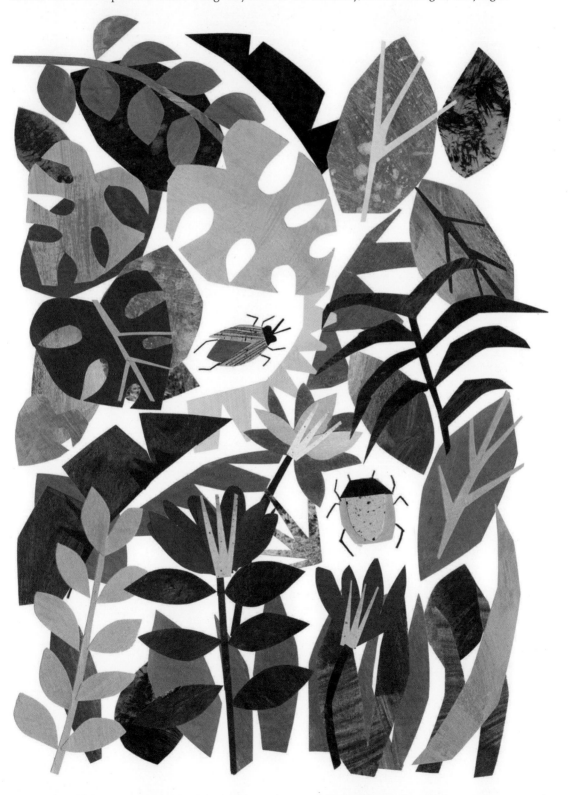

LANDSCAPES AND BUILDING A SCENE

By now, you hopefully have a few ideas about what kind of collage you would like to create and what kinds of elements you want to include. We've looked at many different collage elements individually, but what about placing them together to form an actual scene? In this next section we are going to look at the basic principles of composition and how we can create artworks that help lead our eyes around a page and make a focal point. We are also going to put our training into practice and look at a few different scenes and landscapes, like a seaside, mountain, and park, that often inspire my artwork and will hopefully serve as a jumping-off point for creating your own.

BASIC COMPOSITION

Composition is useful when putting a picture together, but it's not something to get hung up on. We naturally have a way of looking at things, so more often than not what you create will look beautiful whether or not you take the following composition notes into consideration.

The rule of thirds: This rule is fairly straightforward. Imagine drawing two evenly spaced horizontal lines and vertical lines on your artwork. Your page now will have been divided into nine spaces. This rule states that the points of interest in your picture should sit on—or intersect (cut through)—those lines or points. This is useful if you want to put something on the horizon and something else in front of it, and for creating a sense of balance in your art.

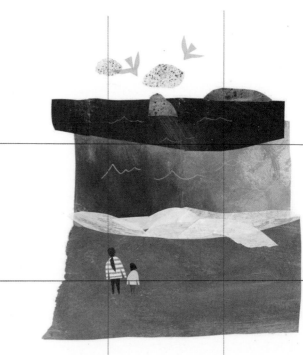

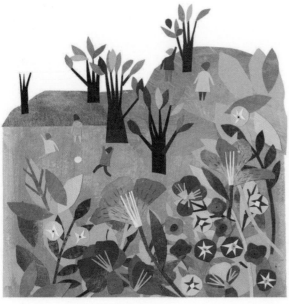

Depth and proportion: You can create drama and depth in a landscape by playing with the size and placement of different elements. Increasing the size of something in the foreground so as to minimize the objects in the background is a great way to play with the viewer's perspective and draw them into your artwork.

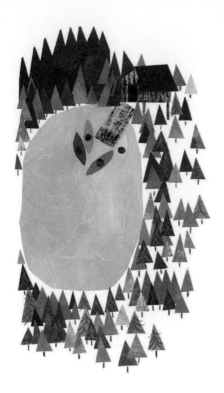

Framing: Use elements of your picture to frame those things you want to highlight in the artwork. This works nicely in landscapes, where you can use the background elements like trees and hills to frame a central image.

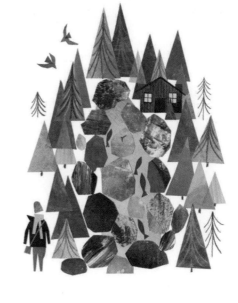

Leading the eye: The idea behind this rule is that our eyes naturally follow any lines that move throughout a piece of art. So, what about including a little path within your collage, or a river or stream meandering through the scene, to help lead your eye around the page?

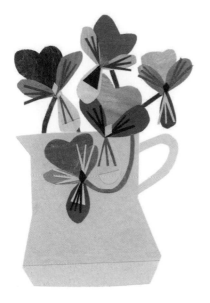

Off-center: Our eyes naturally settle on things slightly off-center, especially when they make an image asymmetrical. Try moving the main focal points of your artwork to the slight upper-right for a more aesthetically pleasing picture. This need not apply only to landscapes; lots of artwork comes alive when it draws the eye away from the center.

LANDSCAPE ELEMENTS

Now that we know how to create all these bugs, plants, and people, what about a base for them to sit on? In collage, your best bet is to patchwork a background together using different textures to create dynamic scenes full of character and depth. For clouds, I use tissue that I painted white and gray, which has a lovely transparency when it sits over a pale blue sky or mountaintop.

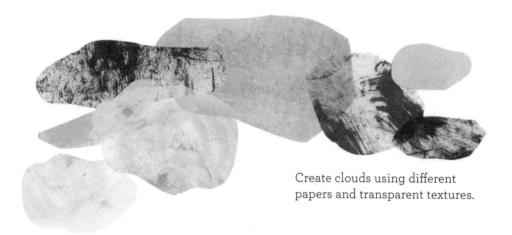

Create clouds using different papers and transparent textures.

For sea and water landscapes, I like to combine varying shades of blue and turquoise in long strips, and then finish them off with more of that painted white tissue for a frothy wave. For rocks and mountains, paper that has been roughly painted using an almost-dry brush and tiny amount of ink creates fantastic texture, while a piece of painted green paper layered with individual strands of tall grass will make a great meadow or hilltop. The key to working with large surfaces of color is to make sure you get plenty of texture in when painting your paper. Otherwise, the artwork can tend to look a bit flat.

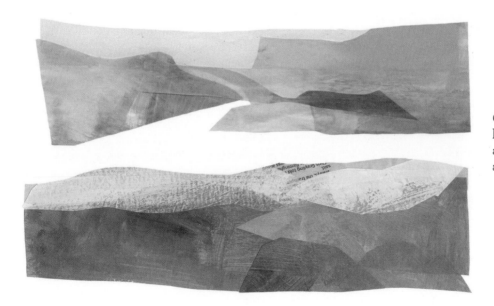

Overlay different hues of blue, gray, and green papers for a frothy, wild sea.

Use a textured gray paper for mountains and cliffs.

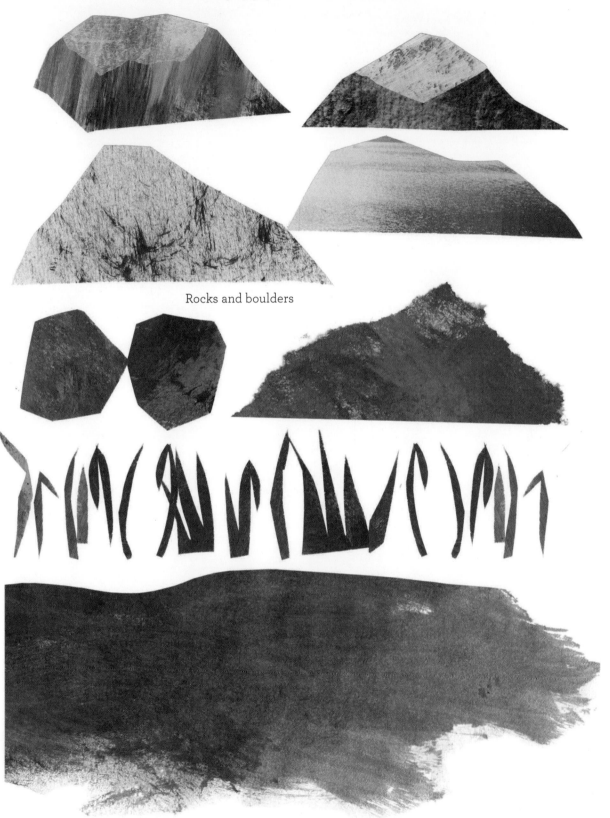

Rocks and boulders

Cut out long stems of grass and place over large areas of green meadows.

NATURE SCENES

I recently created an artwork of the nature reserve near where my folks live. The place is teeming with nature and plant life. Since I live in the city away from nature, I worked from photos rather than creating a detailed portrayal of a specific place. I also wanted to create a general feeling for the place rather than a direct interpretation.

For the focal point of my collage, I chose a curving river, which plays an important role in the nature reserve. I wanted the artwork to have movement, so I placed rocks and foliage on the curves to emphasize the flow of the piece. The colors in the reserve are absolutely stunning, and even though the photos were taken in late summer, the oak leaves were already starting to turn pink, brown, and orange, which I included to bring contrast to the artwork.

Once I added in more of the foliage, I started thinking about framing the picture. I decided to use the leaves at the top of the page and the bright pink wildflower at the bottom in the foreground, thus creating depth while bringing the viewer's eyes toward the central subjects. A few little details like some butterflies helped to create not only context, but also more perspective and scale in the artwork.

I used a lot of green in this piece, so I wanted to make sure the oranges and reds were balanced throughout the artwork and not clumped together. The river reflects as vibrant green in real life, but the soft gray-blue provided a better contrast and didn't get lost with the greens of the trees and foliage. Don't be afraid to take a bit of creative license if something isn't working out. Layer pieces slowly and move them around the page. That said, it's important to know when to stop. If you feel like your collage is becoming cluttered or confusing, take a break, walk away, and come back to it.

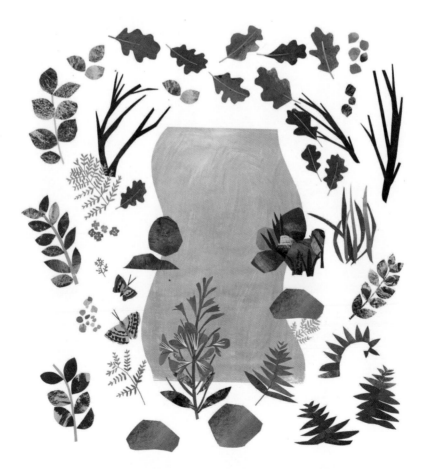

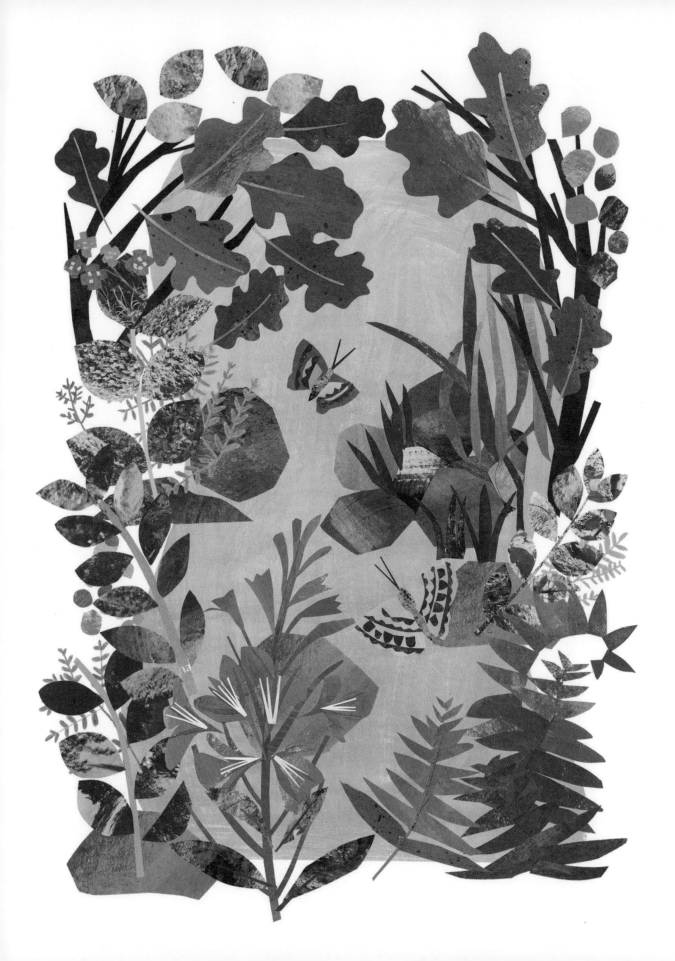

STEP-BY-STEP: HOUSE IN THE HIGHLANDS

My parents were both born in Scotland, so it's a country that I've visited often and find beautiful and majestic. The Highlands are awe-inspiring, and I couldn't resist creating a little interpretation after a recent trip to visit them.

1. You guessed it—this one is all about the greens and grays. Gather up lots of different dark and grassy shades, and snip a few different segments with a mountain shape for the top. Color into the gray of the mountain with some different-colored green pencils that blends better with the other sections. Adhere the pieces atop one another, and you have your base.

2. Instead of using your scissors, tear some different shades of green paper so the raggedy edges are visible, creating the impression of long grass and a rugged landscape. You can also color the paper a little with dark brown and purple to give the impression of wild heather and muddy soil. Adhere them at slightly different angles running parallel to—and overlapping—the other chunkier segments to break them up a bit.

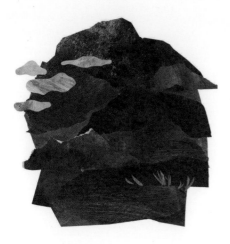

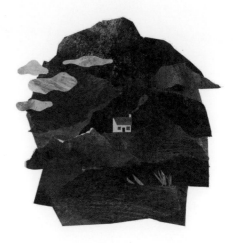

3. Break up all that green with some low-level clouds using the textured gray-white paper that comes with this book. Then, add a few strands of grass in the foreground. This is great for adding not only interesting detail, but also scale to the piece. We want the hills to look like they're looming over the meadow.

4. Finally, your cottage! I suggest snipping a white rectangle as small as you can manage. Then add a tiny gray roof, a little window, and tiny puffs of smoke to make the whole scene seem huge. Who wouldn't want to hole up in that adorable cottage with a fire going?

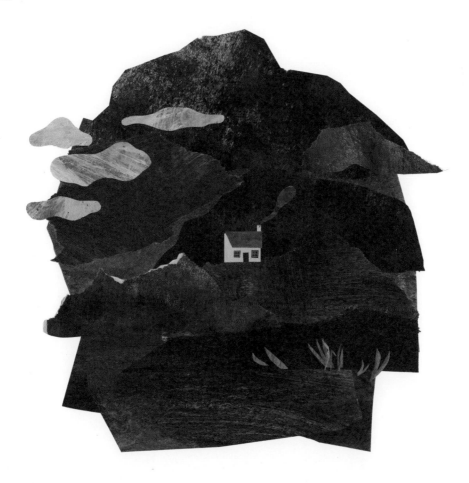

MOUNTAIN SCENES

Bearing our previous landscape's steps in mind, let's consider what other landscapes you can create along with the important aspects of them that you want to show. After the seaside, there is nowhere I would rather be than the mountains and forest. There's nothing more fun than hiking deep in the cool woods, surrounded by fresh piney trees, chirping birds, and chittering insects. But there's also plenty to be said for reaching the top of a mountain and looking out onto breathtaking scenery.

By adding little people on the summit of your mountain, you give the artwork height and scale, and create a focal point that draws the eye and gives the rest of the collage a sense of perspective. I layered the tissue paper that creates the rocks and mountains, making sure to include plenty of contrasting textures. For the forest, you should include trees of different sizes, colors, and textures so as to create depth. On the opposite page, I used our framing technique, and added a stream to lead the eye through the picture. The rocks and trees on the curves, meanwhile, suggest movement, letting us to both observe and explore.

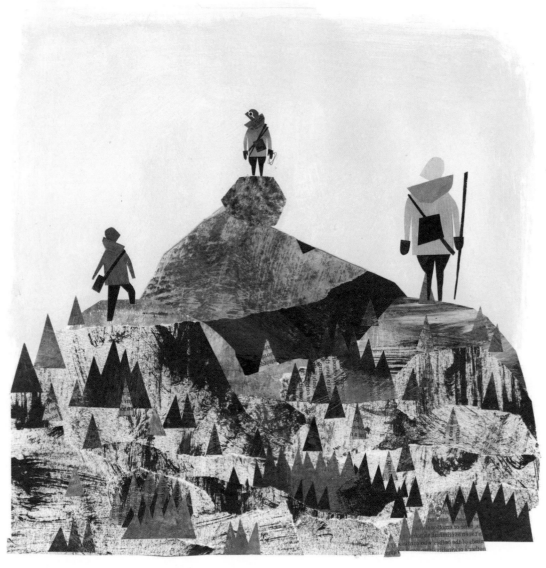

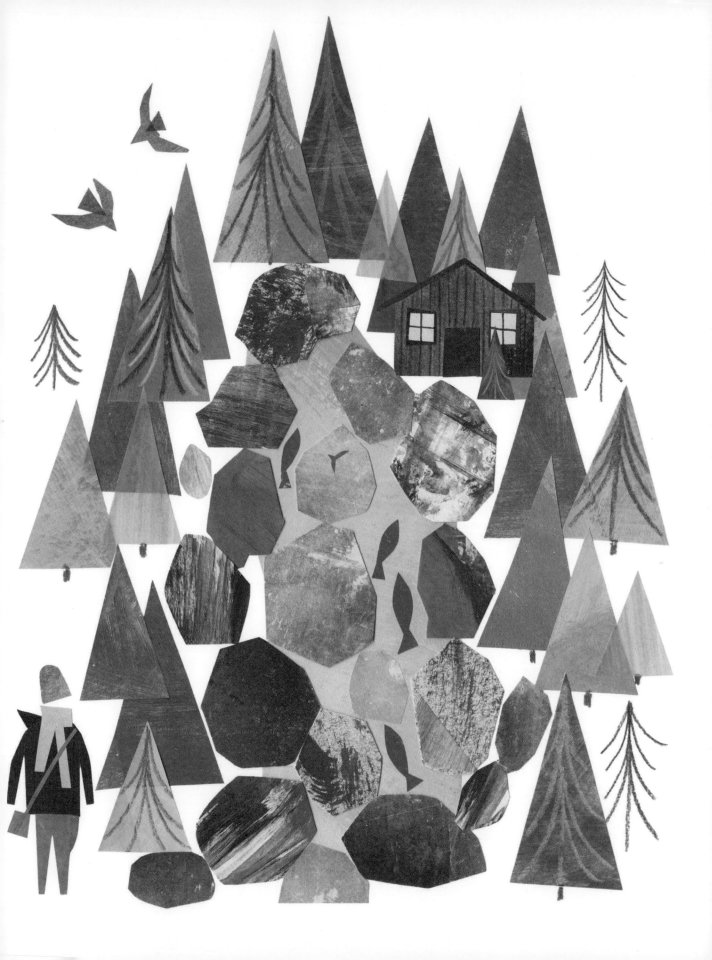

PARK SCENES

Being a nature lover while living in a city, I am always drawn to parks, and they have become a mainstay of my work. I have created two different park scenes. The first one uses a lot of lovely sunny foliage in the foreground, but also creates perspective with the addition of a few tiny people playing in the background. This sense of distance and movement makes the viewer want to dive through the bushes and join in with their game.

In my second collage, I have used a lake as a focal point, and framed it using bright colorful trees and little houses throughout. The idea is to create the feeling of finding an oasis in the middle of a big city, a time out where one can break free of the busy routine of the city and relax on a rowboat—if you're lucky enough to know anyone with a boat in the city.

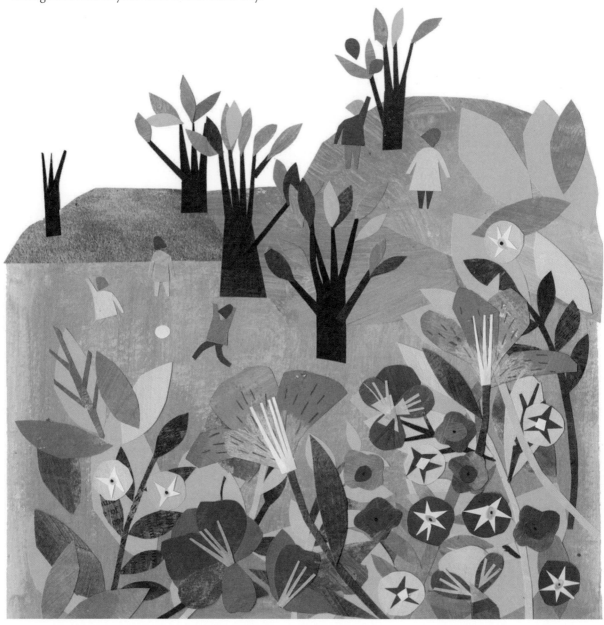

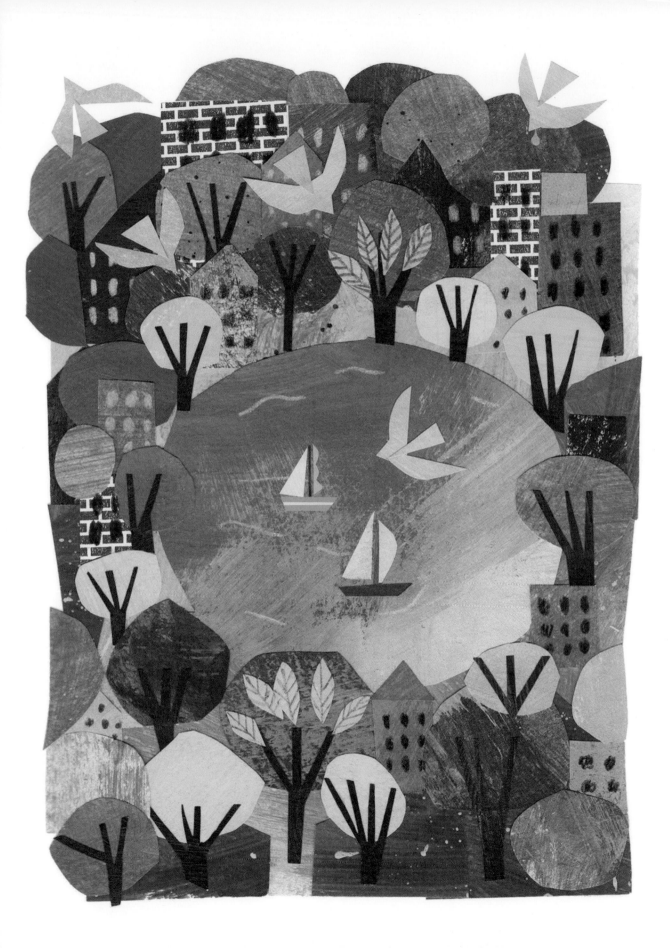

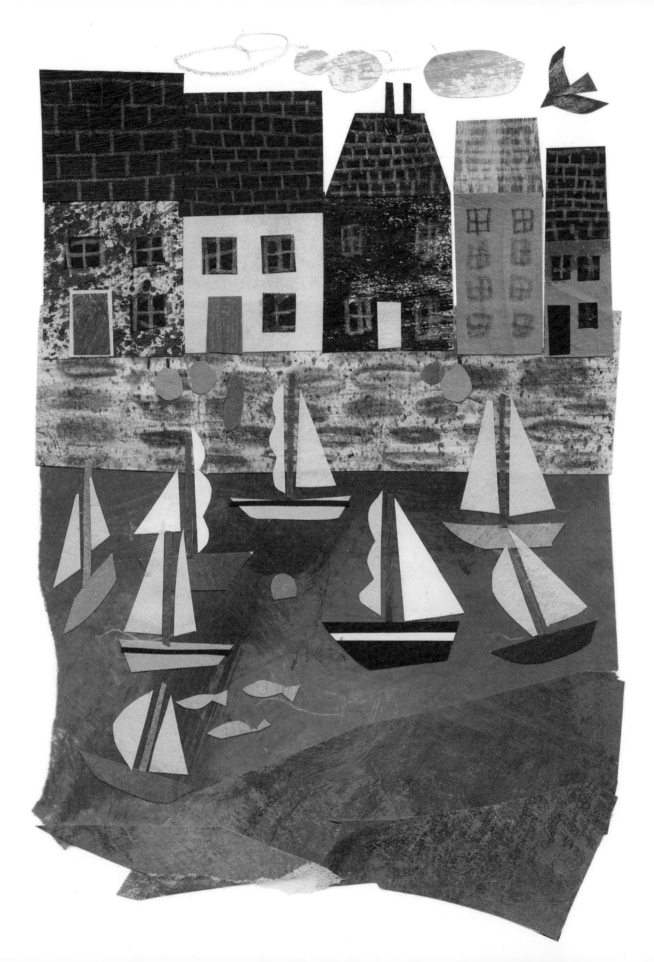

SEASIDE SCENES

Finally, my favorite landscape of all: the sea! I have had a long-term love affair with the seaside from a young age, and I adore idyllic little fishing villages and beaches. While I don't create those sorts of seaside collages very often (between you and me, I feel I can rarely do them justice), when I do, I like them to burst with personality and texture. I try to incorporate lots of different mark-making techniques and a variety of hand-painted and found papers that reflect the distinct flavor of these surroundings. From weather-beaten fishermen's cottages to chocolate-box artists' studios, the houses of seaside villages have a life all their own.

Both of these artworks loosely adhere to the rule of thirds, but my primary goal with these was to showcase all the things I love the most about the place. Both are inspired by the harbor, but each has a distinct feel. For romantic landscapes, think about the specific characteristics of a particular locale, and make sure to add plenty of little points of interests like specific houses, people, and birds. Remember: while the rules are important, your unique vision and feeling of a place should be your top priority.

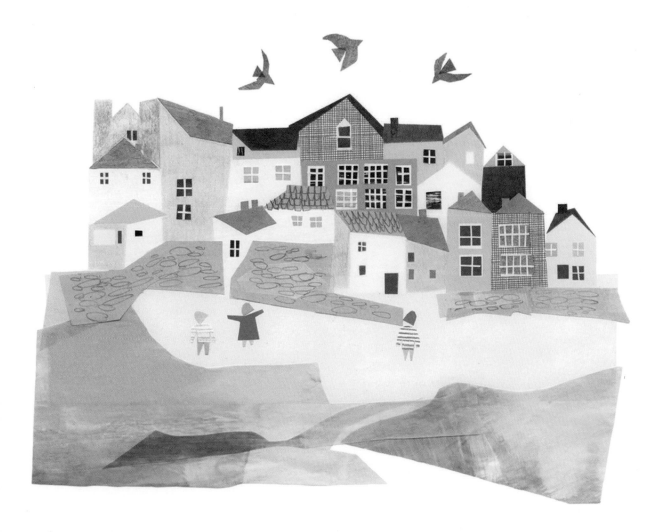

STEP-BY-STEP: SEASIDE TOWN

Since I was a little girl, I've been a fan of seaside towns and all that comes with them—fish and chips, naughty seagulls, and crabbing off the harbor's edge. The harbor town I snipped here is based on Cornwall, England, but you should look into your memories and find one that resonates with you.

1. Pull out a neutral-colored paper from the back of this book, and draw some cobblestones on it. Cut it out so it's a long rectangle shape. That's your harbor wall.

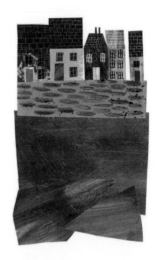

2. Beneath the wall, add a few large segments of patterned blue paper to create your sea. Put certain pieces of paper at an angle, or make their patterns against the grain of its neighbors, to give the water a sense of movement.

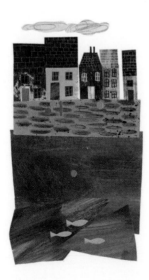

3. Cut out five different-colored and textured rectangle shapes for houses. For roofs, cut out squares and use a colored pencil to add a tile pattern to them.

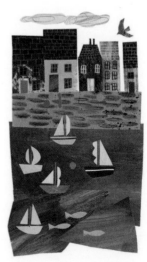

4. Bring the little houses to life with tiny windows embellished with different-colored frames and doors. Mine are simple, but you could incorporate a variety of fun shapes and sizes into yours.

5. Details! I love the moody colors evocative of a Cornish coastline contrasting with bright pops of pink, orange, and coral from the buoys. Capture these by snipping some simple circles and sausage shapes out of brightly colored paper. A few fish darting around the water gives the scene personality and charm. Use a lighter colored blue so they look like shimmering mackerel or sardines. Finally, some gray pencil squiggles on an off-white or gray paper make a fabulous grumpy cloud hovering above the harbor houses.

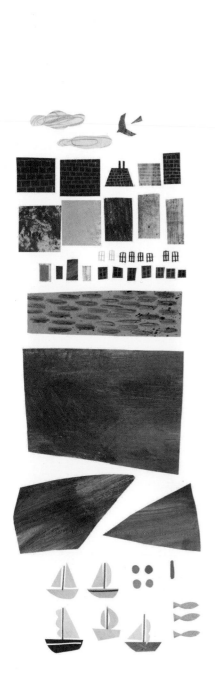

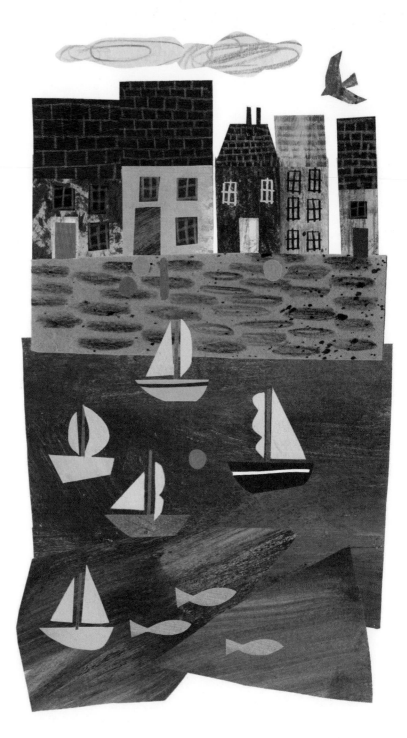

CREATING ARTWORK FROM PHOTOS

Something I love is creating a stand-alone collage from a picture I've taken, translating the essence of that photo into something that sums up my personal experience. This next section will show some examples of how you could approach this kind of collage. Why not go through some of the photos you've taken and create a picture out of them? It doesn't even have to be an artwork of one photo; it could be a lot of different photos taken from one experience that culminate in a single collage. Is there a focal point in the photo or have you taken the picture in a particular composition that you would like to translate via collage? Is there something in the picture that sparks other visuals from a bigger experience? These collages are just my artistic interpretation of my personal experiences. Now it's your turn to have a go at your own. Happy snipping!

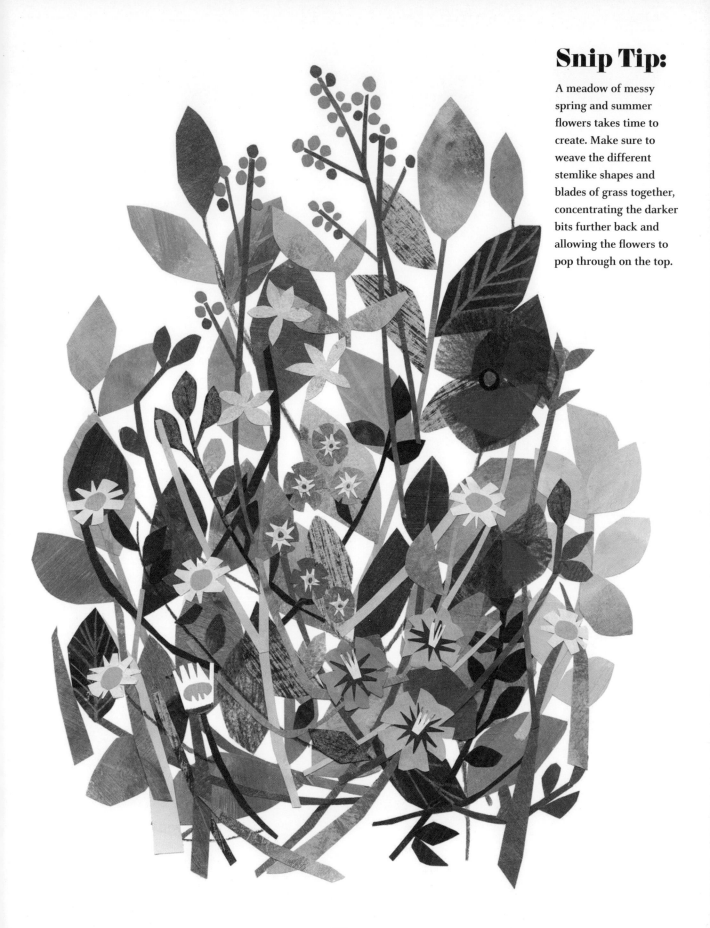

A meadow of messy spring and summer flowers takes time to create. Make sure to weave the different stemlike shapes and blades of grass together, concentrating the darker bits further back and allowing the flowers to pop through on the top.

HOUSE PORTRAIT

I really enjoy creating house portraits, and have designed a few as commissions for people who want their home immortalized in collage. This is one I did for Laura of her home in Portland, Oregon. Her house is painted a lovely pale gray with a beautiful tree at the front. I've embellished it further with a big, blousy border. Again, sometimes it's fun to take creative license and add in special bits— so long as it's okay with the client. Rather than trying to collage a scene exactly as it appears in real life, try collaging the essence of the place instead.

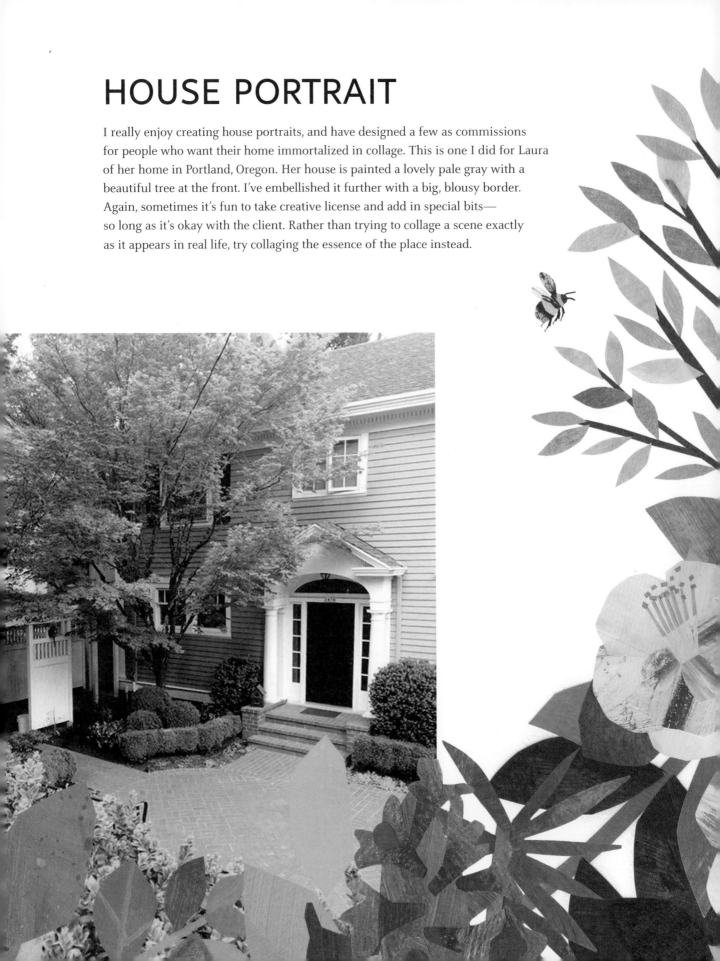

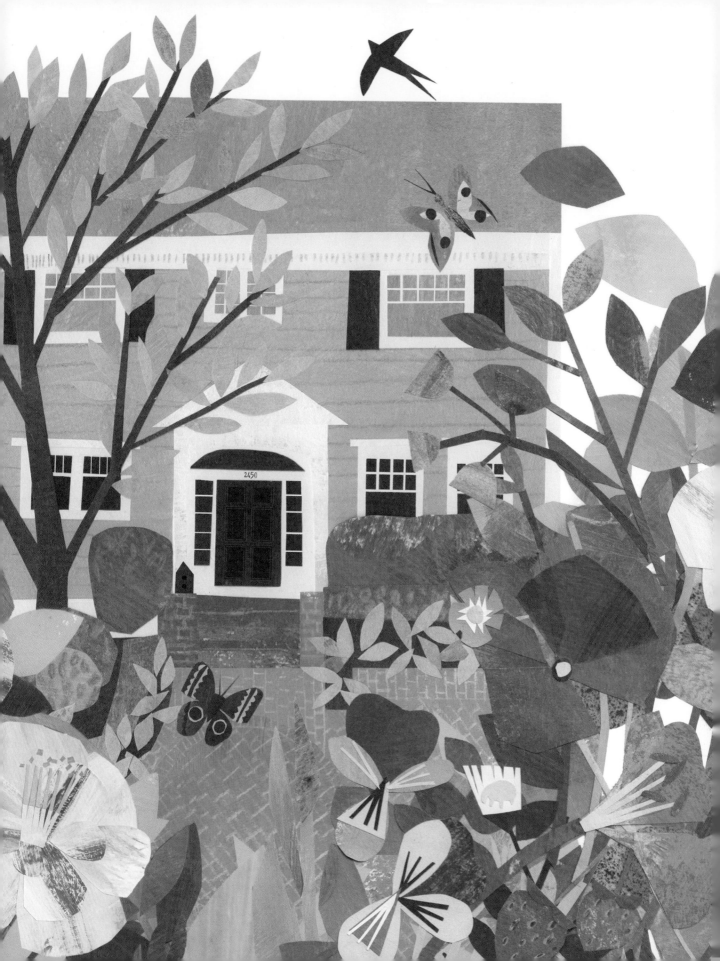

Snip Tip:

Have fun with composition. I've chosen a few practical and obvious garden things like gardening gloves, spade, and watering can to sit alongside little joyful garden elements. The bright blooms and buzzing bees create a pattern-inspired piece.

IN THE GARDEN

I'm not a great gardener, but I am a passionate one. I have lived in a few different places around the city where I haven't been able to grow anything other than little houseplants, so to be currently living somewhere that has flowerbeds is a bit of a dream. I made this little artwork for myself and my partner Kev, because while any kind of afternoon spent in the yard is a good one, it's especially wonderful when it's spent with someone special.

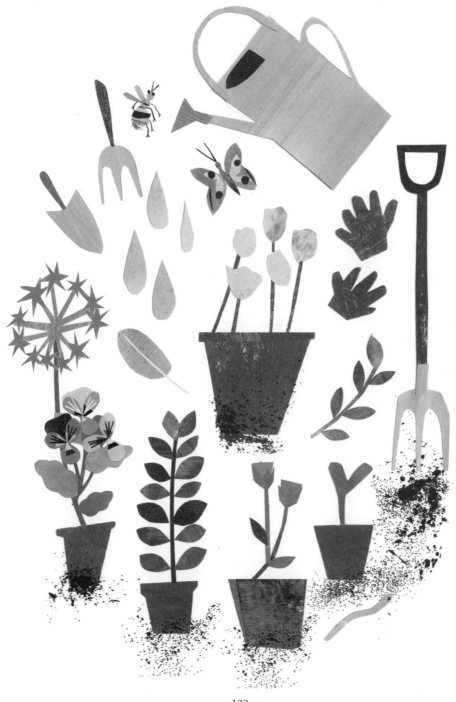

RECIPE

I don't love cooking. Thankfully, I have lots of family and friends who do. However, there is one thing I'll make all through autumn, and that is a delicious, rich, ratatouille chock-full of vegetables. It's one of my absolute favorite things to make, both as a dish and as a collage. For me, ratatouille conjures up images of cozy autumn evenings around crackling fires, long games of Scrabble, and perfect moments of relaxed joy. But if ratatouille doesn't get you going, how about creating your own collaged recipe, or a special recipe for someone else? Maybe it could be a meal from a first date or an anniversary that your partner will remember, or a big beautiful cake marking an important birthday. Food collages are fun no matter what dish is being served.

ratatouille

Plum tomatoes
Salt and Pepper
Olive oil.
Mixed herbs
cherry tomatoes
1x Red onion
1x Aubergine
2x courgette
1x Red Pepper
Balsamic Vinegar

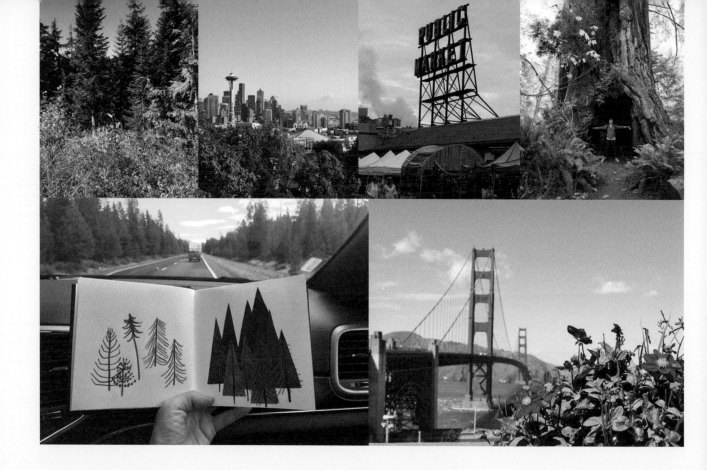

PERSONALIZED MAPS

I love to travel, and I love to document my travels using little drawings and collages in my sketchbook. Last year I did the most amazing road trip down the West Coast of the United States and saw just the most incredible array of landscapes and architecture. Other than the billions of photos I took, along with maps and tickets I collected, I wanted to create a memory of the actual route we took, and made a colorful artwork map of some of the places where we stopped. This kind of collage is an easy and fun way to reminisce about your trip in a personal way.

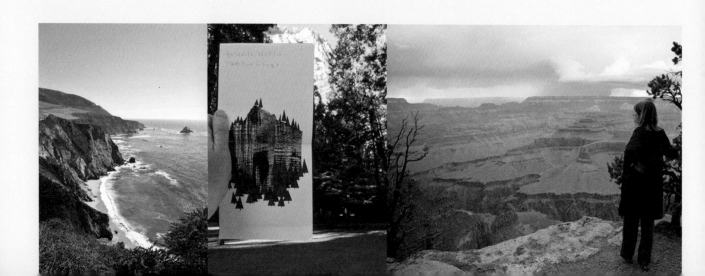

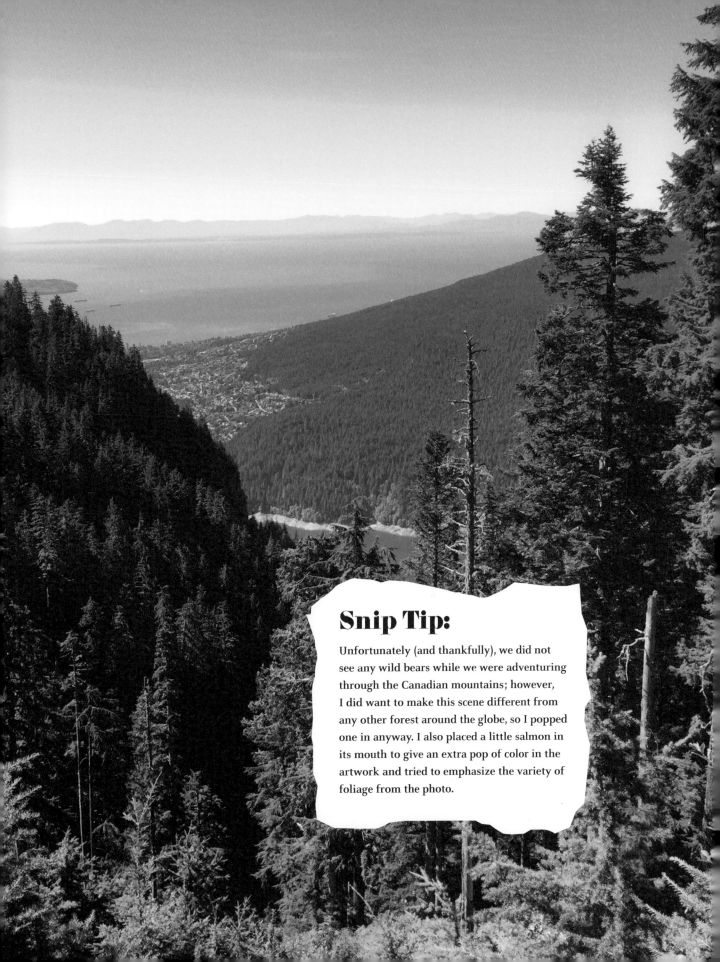

Snip Tip:

Unfortunately (and thankfully), we did not see any wild bears while we were adventuring through the Canadian mountains; however, I did want to make this scene different from any other forest around the globe, so I popped one in anyway. I also placed a little salmon in its mouth to give an extra pop of color in the artwork and tried to emphasize the variety of foliage from the photo.

SCOTTISH HIGHLANDS

I took this picture while whizzing by in a car. I wanted to emphasize the sheer scale and drama of the highlands. Incorporating lots of lovely craggy mountain texture and making the house as tiny as my cutting would allow, and some low-lying clouds, make this mighty Munro seem absolutely massive!

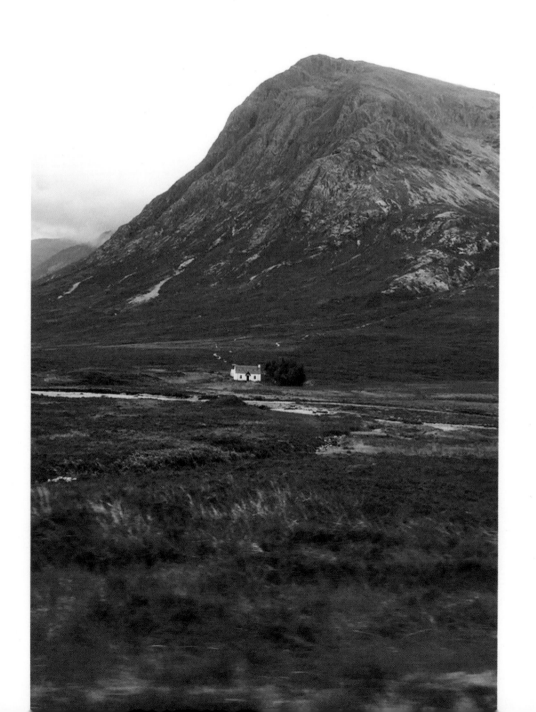

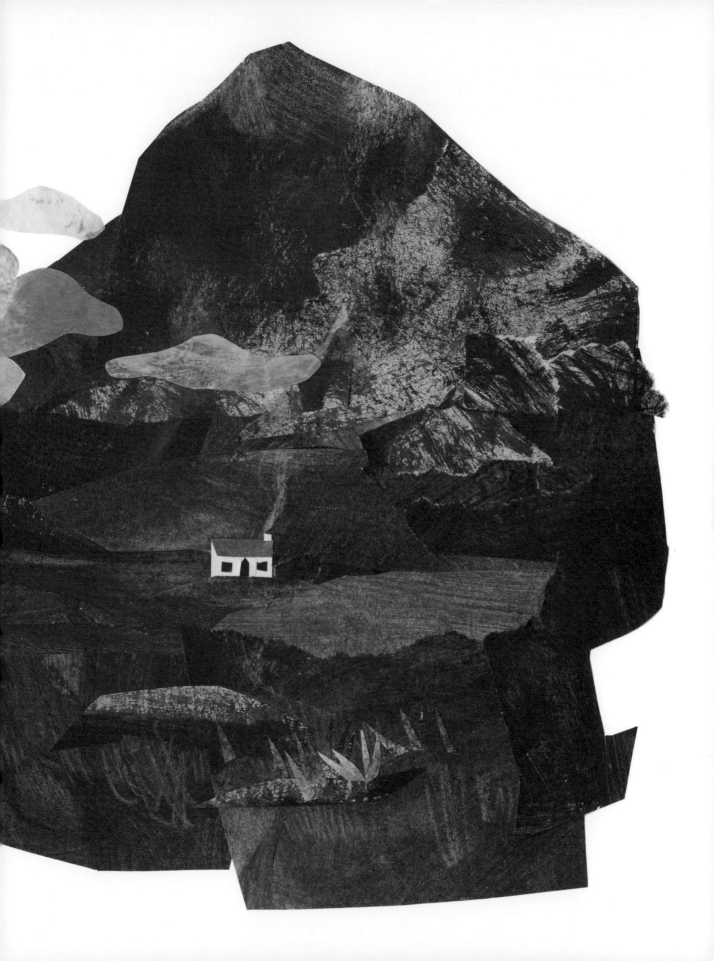

AUTUMN IN THE PARK

I enjoy autumn in the park almost as much as spring. The colors are phenomenal, and everyone is having so much fun playing in the leaves. This is the time of year you will find me picking up autumnal treasures and pressing colorful and skeleton leaves. While everything may look a bit drab, I like to try and suggest a slightly higher saturation of color and really embellish what's there. Make a seemingly pink-orange leaf bright cerise with flecks of vermillion.

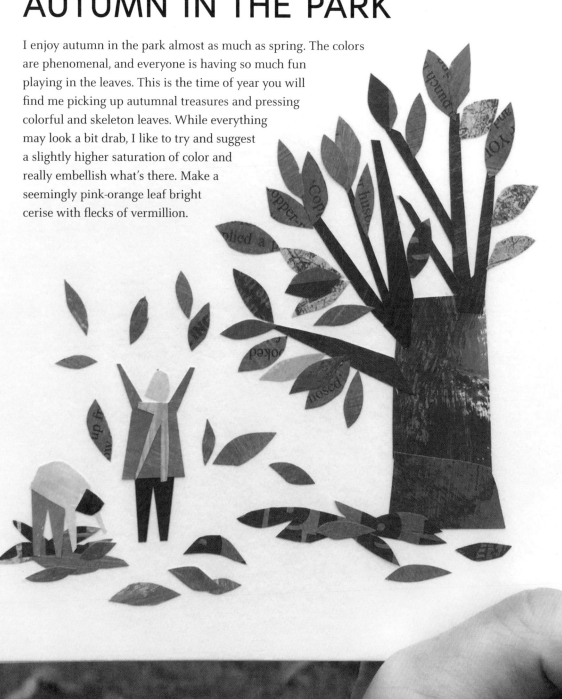

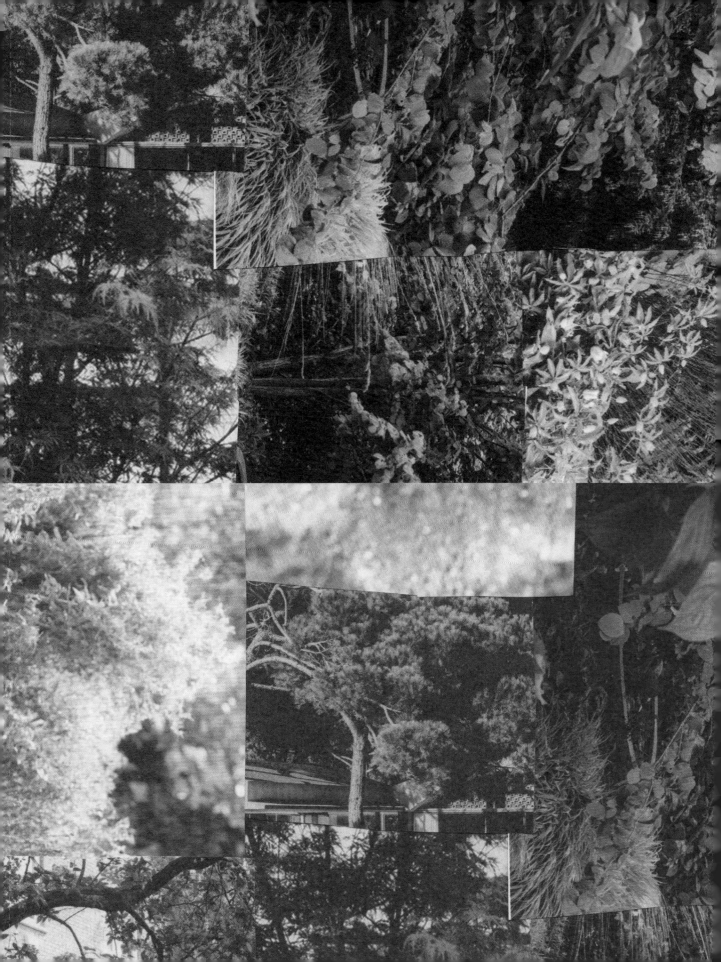

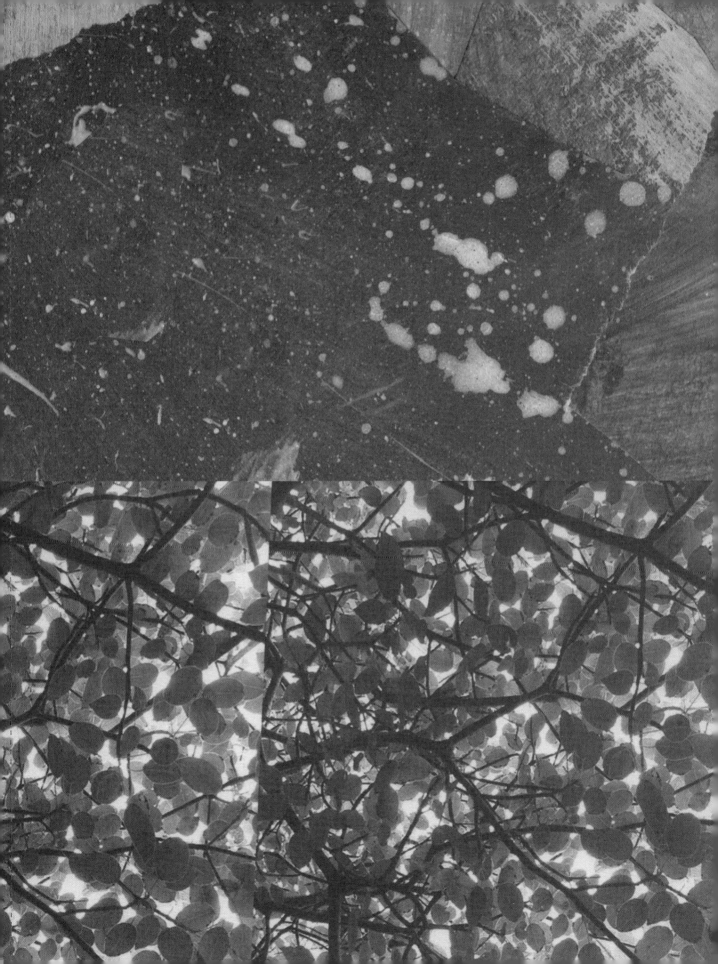

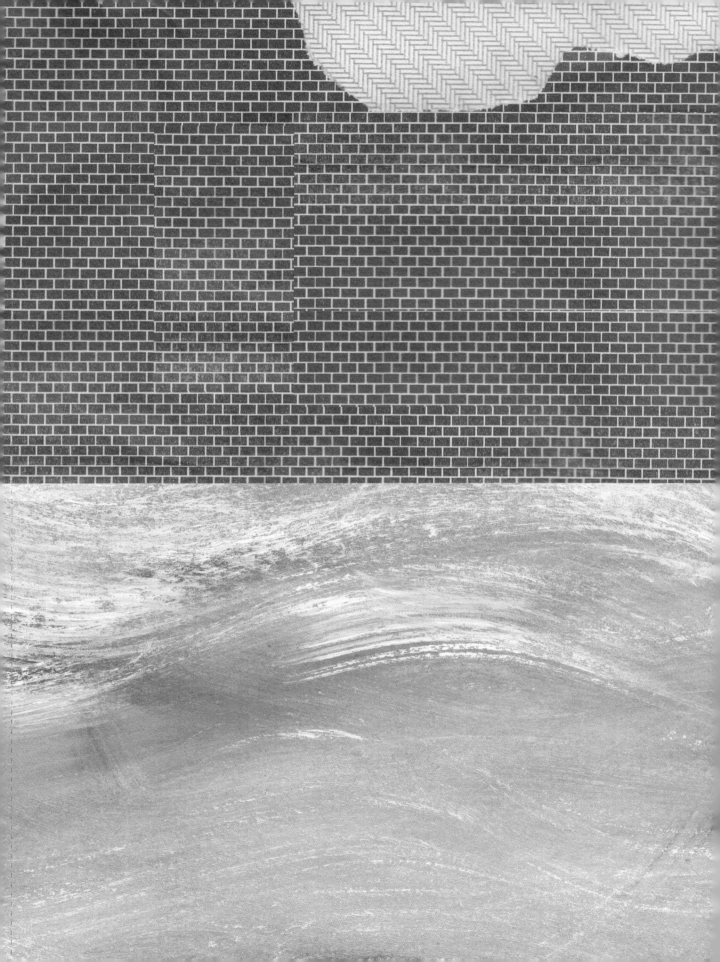

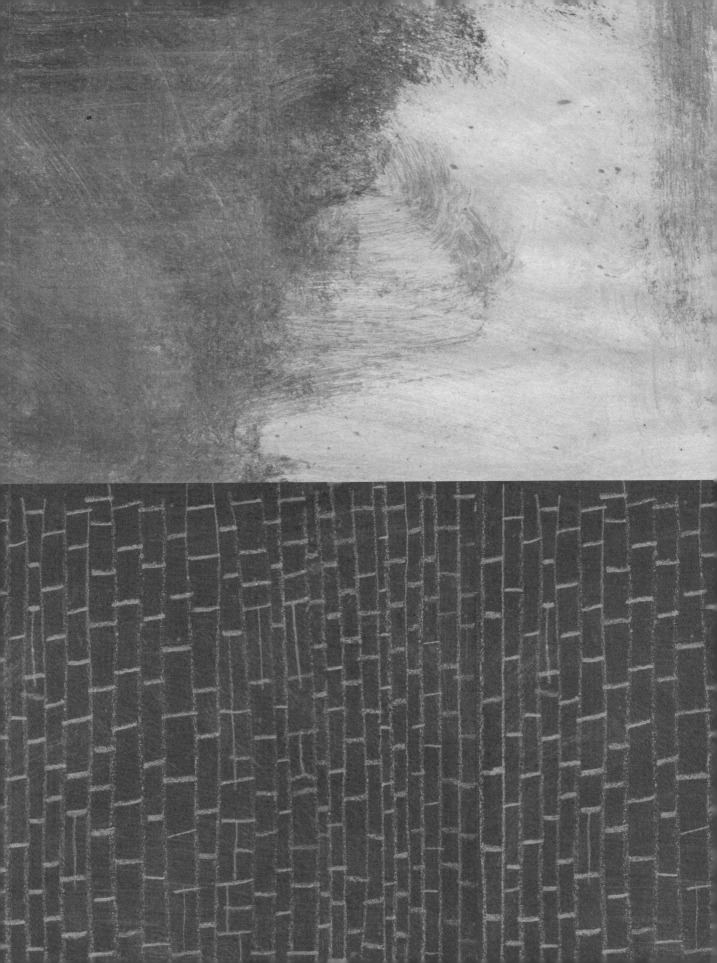

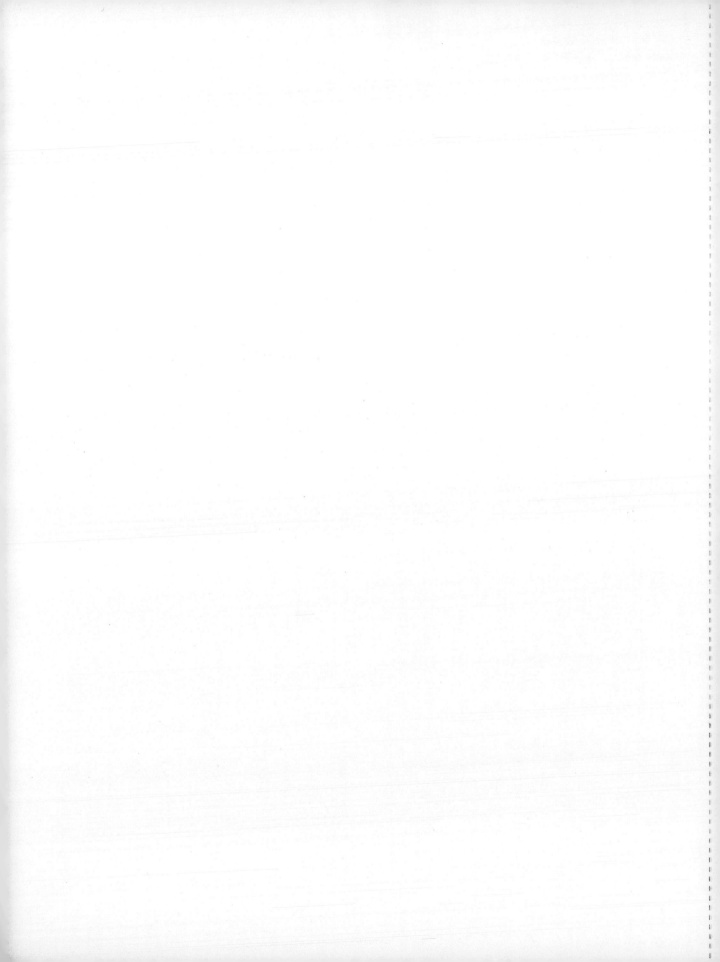

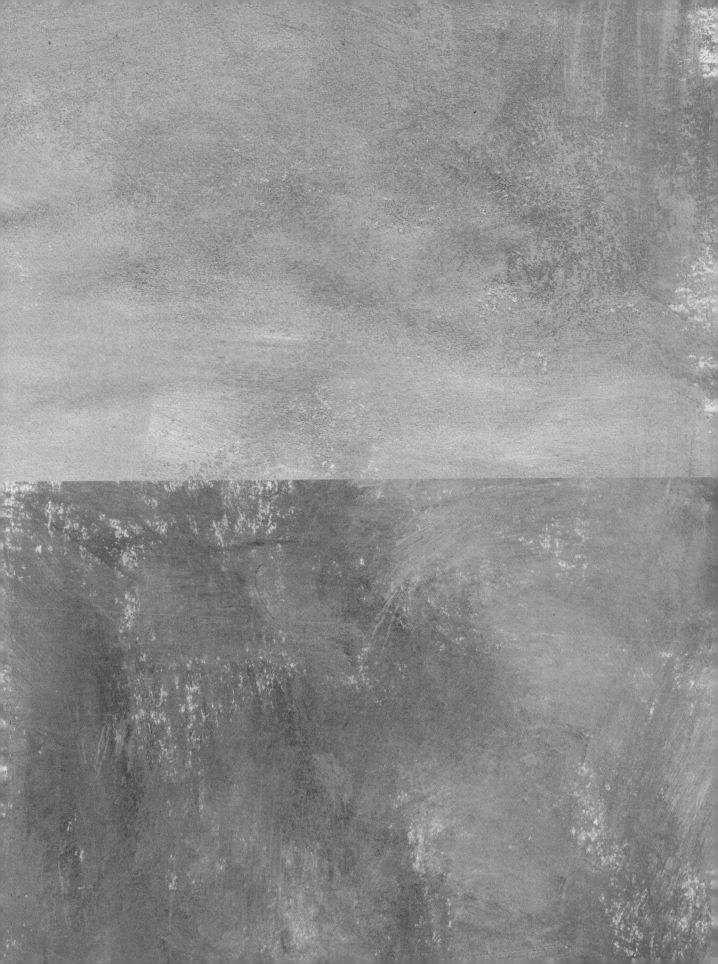

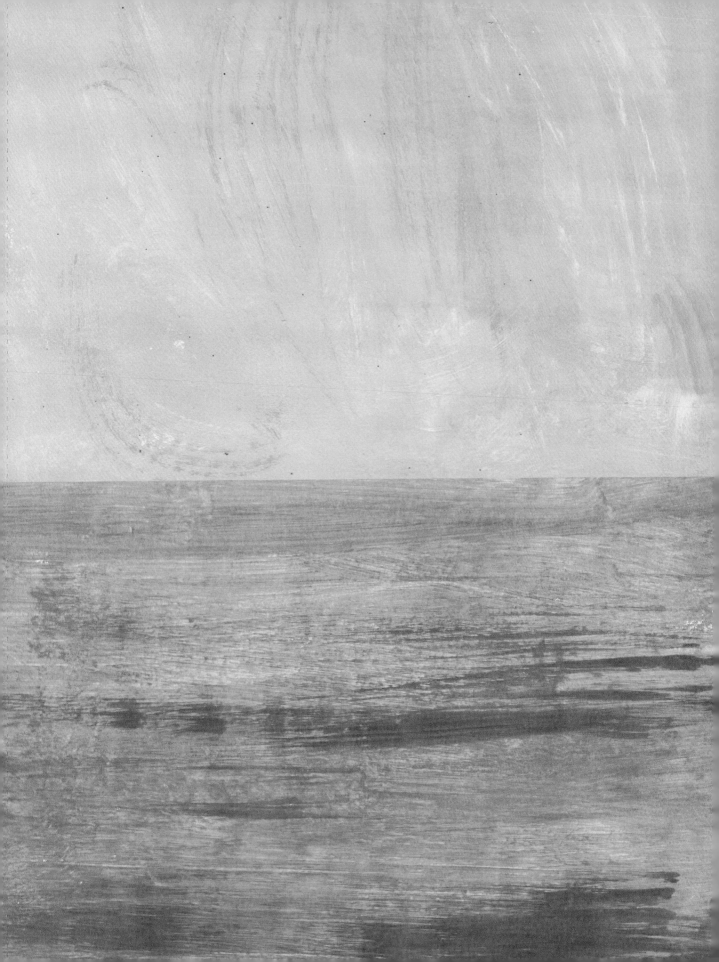